THE ARTIST'S
PAINTING LIBRARY

REALIST TECHNIQUES IN WATER MEDIA

BY RUDY DE REYNA
FOREWORD BY WENDON BLAKE

WATSON-GUPTILL PUBLICATIONS/NEW YORK

First published 1984 in New York by Watson-Guptill Publications,
a division of Billboard Publications, Inc.,
1515 Broadway, New York, N.Y. 10036

Library of Congress Cataloging in Publication Data
De Reyna, Rudy,
 Realist techniques in water media.
 Includes index.
 1. Water-color painting—Technique. I. Title.
ND2420.D4 1984 751.42 84-2365
ISBN 0-8230-4511-0

Distributed in the United Kingdom by Phaidon Press Ltd., Littlegate
House, St. Ebbe's St., Oxford

Manufactured in Hong Kong

2 3 4 5 6 7 8 9/88 87 86

CONTENTS

Realist Techniques in Water Media. Whether it's called "magic realism," "sharp focus realism," "photo realism," or just plain "realism," the sharp-focus approach to painting has fascinated artists for 500 years. Rudy De Reyna was a master of this popular brand of realism, recording the forms, colors, textures, and details of nature with great precision. His books have taught these methods to hundreds of thousands of readers. The water-based painting media—transparent watercolor, opaque watercolor (or gouache), and acrylic—are ideally suited for the gradual buildup of texture and detail. Rudy De Reyna shows you how to use all three of these media with the extraordinary precision that's the hallmark of his style.

Tools and Techniques. De Reyna begins with a brief refresher course in the techniques that are common to all the water media. He shows you how to lay washes on dry *and* damp paper; how to create a variety of drybrush strokes; how to produce various other textures that include scumbling, stippling, and thick passages (in combination with transparent glazes); and how to use painting knives and razor blades.

Watercolor Basics. When people say *watercolor,* they normally mean transparent watercolor. De Reyna demonstrates the fundamental watercolor washes and strokes in a study of sand dunes and beach grass. He then demonstrates the wet-in-wet technique—working on wet paper to create soft edges—in a dramatic study of a stormy sky, and he finishes the demonstration on dry paper for the hard-edged details of the landscape.

Opaque Watercolor Basics. For many readers, opaque watercolor (often called gouache or designer's colors) may be unfamiliar. So the author devotes particular attention to the basics of this versatile medium. He demonstrates opaque watercolor washes in a still life of a basket of apples; expressive brushwork in a study of the rough texture of an old tree; drybrush and glazing in a study of a weathered window and the crumbling masonry of an old house; and the impasto technique—which means strokes of thick color—in a closeup of a rock formation.

Acrylic Basics. De Reyna reviews the basic acrylic techniques, showing how to use acrylic in opaque *and* transparent passages in a complex study of the varied textures of a stone wall, wooden gate, old tree, and clumps of weeds; how to combine thick and thin color in a painting of a rocky cliff on a pebbly beach, with a luminous background of sea and sky; and how to use the impasto technique in a closeup of a weathered wooden door and the stones of an old house.

Watercolor Demonstrations in Color. Having covered the fundamentals, the author then paints a series of demonstrations of popular subjects in color. The watercolor demonstrations include a still life in which De Reyna shows how to use transparent watercolor to capture the lively hues, textures, and details of a group of onions; a landscape with a cluster of old, wooden buildings and a dramatic sky; and a coastal scene of fishing shacks, wharves, and the pattern of rippling water.

Opaque Watercolor Demonstrations in Color. De Reyna also begins the opaque watercolor demonstrations with a still life—a study of fruit in a basket—and then paints a landscape of tree trunks, branches, grass, and weeds; a coastal scene of weathered shacks, sand, beach grass, sea, and sky; and a portrait of a young woman with subtle color gradations in the skin and rich detail in the features and hair.

Acrylic Demonstrations in Color. The acrylic demonstrations include a still life of a straw-covered wine bottle, a loaf of bread, and a napkin; an open-air still life of flowerpots on a weathered wooden table, set in front of a stone wall; the precise architectural detail of a bridge over the intricate texture of a marsh; a western landscape that contrasts the hard-edged forms of buttes with the soft-focus shapes of clouds; and a seascape of rocky headlands.

Mixed Media. De Reyna concludes by demonstrating how to combine various water media in a closeup of a rock formation, punctuated by weeds and grasses, and an elaborate study of various fruits, with all their different colors and textures. These final demonstrations emphasize that the water media are a remarkable *family* of painting media, capable of working together to produce paintings of astonishing technical richness and variety.

WENDON BLAKE

Selecting Equipment for Watercolor. I prefer the tube colors by Winsor & Newton for larger works, and the Grumbacher No. 30/17 Symphonic set for small paintings. For compositional sketches and rough, behind-the-scenes work I use Grumbacher's Academy watercolors. The sable brush, pointed and flat, has been the workhorse of watercolor painting for hundreds of years. Unfortunately they are, in the larger sizes, almost prohibitively expensive. However, Robert Simmons has produced White Sable, an excellent synthetic fiber that behaves extraordinarily like the traditional sable hair. Remember that all kinds of brushes—bristle, nylon, stippling, and even toothbrushes—can play a role in the execution of transparent watercolor. Also have on hand a single-edge razor blade, masking liquid, a white Stabilo pencil, paper towels, and a kneaded rubber eraser. For a palette, I use butcher's trays— usually three or four—in various sizes. (Transparent watercolors get unpleasantly gritty when wet again; thus several trays are useful.) Paper is, of course, the acknowledged support for the medium, and of all the brands, I prefer Crescent No. 112, Strathmore, Brainbridge No. 80, Fabriano, and d'Arches. The thinning agent, of course, is water.

Selecting Equipment for Opaque Watercolor. I find the smoothness, the brilliance, and the covering power of Winsor & Newton's Designers Gouache appealing. Another choice for smaller paintings in the studio and for sketching outdoors is the Pelikan 735 E/24 metal box of 24 colors. The cakes soften quickly when moistened, the color is picked up easily, and the brush is spared the rubbing required by some of the other sets. It is comforting to know that brushes congenial to transport watercolor can be just as compatible with one aqueous medium as another. There was a time when it was thought that opaque color was injurious to sable. But, it was the artist who neglected and abused his tools that perpetrated the rumor. All that is needed is a good bath at the end of each day with Ivory or Pears soap. Further assistance in opaque watercolor can be gained from a mat knife, a painting knife, typewriter paper, and matte fixative. Here, too,

the butcher's tray serves as the best palette, but if this is not available a temporary substitute can be a piece of glass with white paper backing taped on to it, a white panel from a discarded refrigerator or stove, or a piece of Masonite that you can enamel yourself. The most universally accepted support for opaque watercolor is illustration board, and for good reason. The surface papers range from rough to smooth, and the backing boards can be either thin for the smaller works, or thick for the larger and more ambitious ones. By using the appropriate thickness you can keep the board from buckling even after repeated wettings. The materials for transparent and opaque colors are so interchangeable that papers for aquarelle are just as suitable for opaques. As transparent color takes advantage of underlying washes for the liveliness of superimposed glazes, so can opaque get the most of colored grounds by letting them show through.

Selecting Equipment for Acrylic. There are nylon brushes which are expressly made for use with acrylic because it can be rather harsh on the regular watercolor brushes. But for those of you who have a hard time with the hard, irresponsive stock of nylon, use your sable brushes with acrylic but *take the utmost care* to rinse them before you lay them aside while painting. Here again, for the best palette, I recommend the butcher's tray and the slant-and-well palette. While you work, continue adding a few drops of water to keep the paint moist. When I am through for the day, I soak my tray in the sink and cover my palette with another slant-and-well palette that fits over it snugly. Sometimes with acrylic paints I use a paper palette that I can strip away to give a clean surface. Aside from the unorthodox tools employed with the previous media, you might like to use an expired credit card, Liquitex gesso, a sponge, and a Pink Pearl eraser as extra tools for the acrylic painting you plan to do. The supports for acrylic are diverse: a plaster wall, paper, acetate, metal, illustration board, gesso panel, cloth, canvas, plywood—you name it. No doubt it is one of the reasons the medium's votaries swear that there's no better.

The pointed sable watercolor brush is the workhorse of all the tools used with water media.

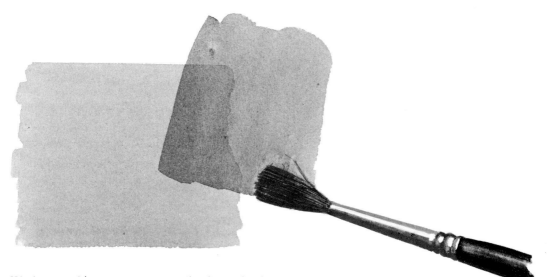

Washes are thin, transparent applications of paint. They provide an excellent means for beginning a painting because you can quickly cover large areas with them.

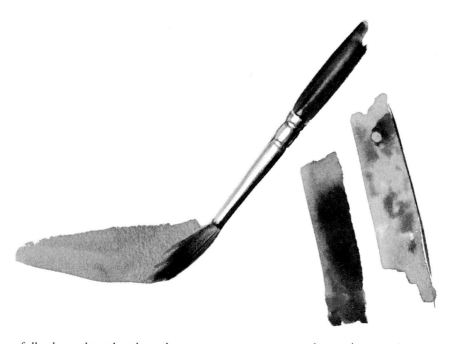

Using a fully charged wet brush on damp paper, you can create the wet-in-wet values you see here.

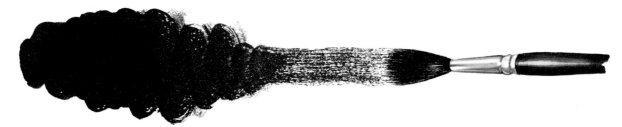

The first step in the drybrush technique is to "empty" your brush of most of its paint—to make it dry.

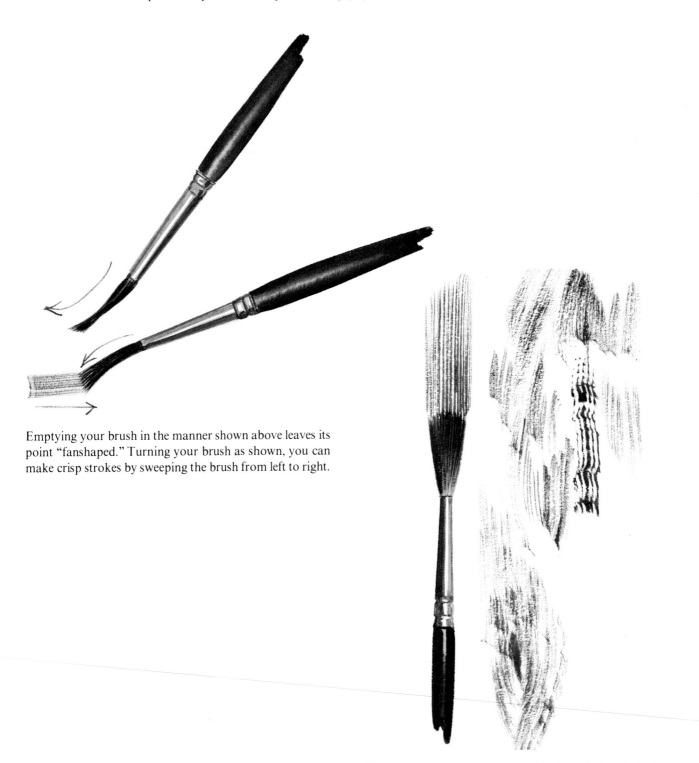

Emptying your brush in the manner shown above leaves its point "fanshaped." Turning your brush as shown, you can make crisp strokes by sweeping the brush from left to right.

Compare the wet-in-wet tones with these drybrush strokes. You can use these two effects singly and in combination.

Here are two views of a drybrush illustrating the use of its edge rather than the broad side of the "fan."

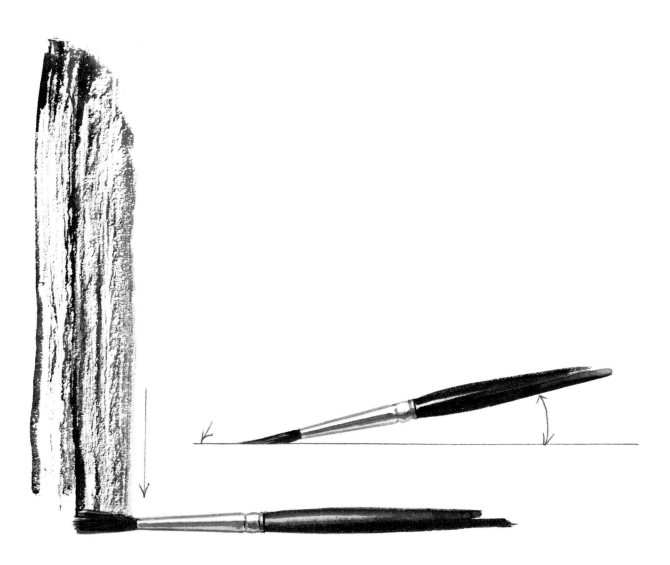

Another way to manipulate a drybrush is shown here. By holding your brush almost flat against a surface and dragging with its entire stock you can produce the texture shown at left.

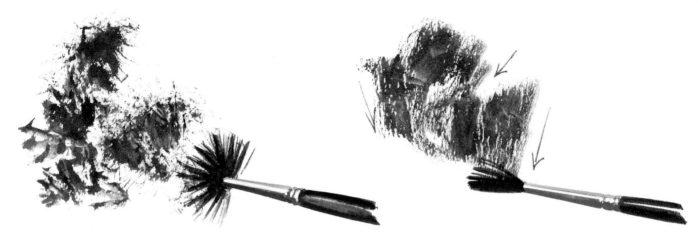

Using a minimum of paint, rub the entire side of the stock of your watercolor brush to produce this effect which I call a scumble.

By holding your brush perpendicular to your painting surface and tapping it vigorously, you can produce the effect shown here which I call stipple.

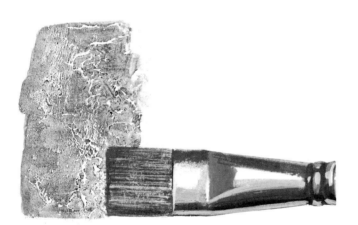

Over a white impasto you can glaze a darker, but transparent, tone. By diluting your paint with more water, you make a glaze thinner and more transparent.

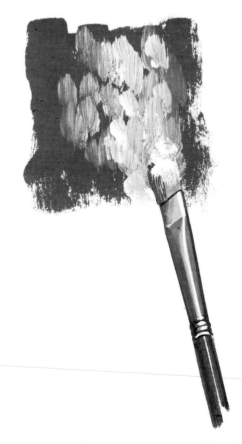

You can also create impasto by applying thick paint with a flat brush.

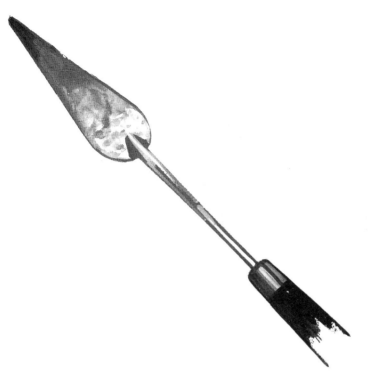

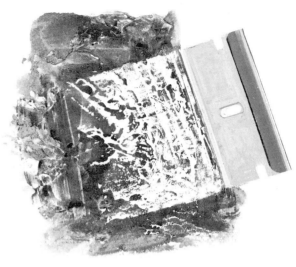

With a painting knife such as this one, you can apply acrylic paint to create impasto effects. By rubbing and patting the paint with your knife, you can create even rougher textures.

Sometimes a glaze, like the one on the facing page (lower left), can subdue the textures of an impasto. When this happens, you can scrape off some of the glaze with a razor blade to bring the texture back.

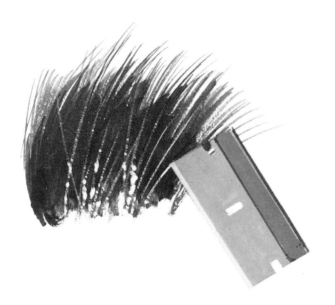

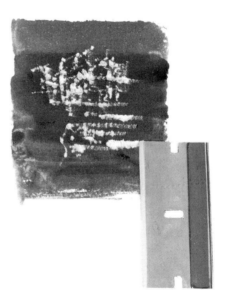

Using just the corner of a razor blade, you can make incisions in dry underpainting to create blades of grass or any other delicate delineation on a dark ground.

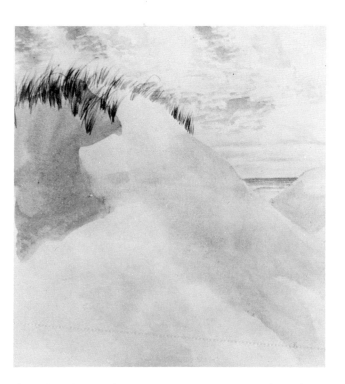

Step 1. First I lightly draw the shape of the dunes with an office pencil. Then I squeeze about ¼″ of Payne's gray into a white saucer. With a No. 3 brush, I dilute the gray and brush it on the dry paper, letting the paper itself describe the shape of the cirrus clouds. Then I indicate the shadow on the left of the large dune with a No. 9 brush and Payne's gray.

Step 2. After wetting the smaller dune and the light (right) side of the large dune with clear water, I dip the brush into the gray pigment for a light tint and work the gray on the wet surface to get the soft-edged configurations. Dipping the No. 2 brush into full-strength Payne's gray, I begin rendering the grass in swift, upward strokes.

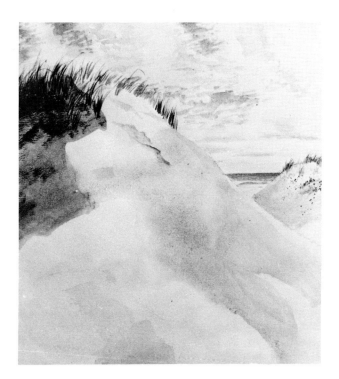

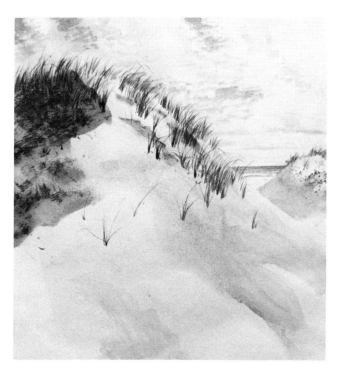

Step 3. With the side of the No. 2 brush I develop the dead grass and roots on the shadow side of the big dune. As you see, I paint the grass in the back first—I think that things in front should be superimposed on those behind. At this stage I also begin indicating the grass on the smaller dune to the right.

Step 4. Here I continue to add more grass in the manner already explained. Then, still using the No. 2 brush, I introduce a few more details into the shadow area of the main dune.

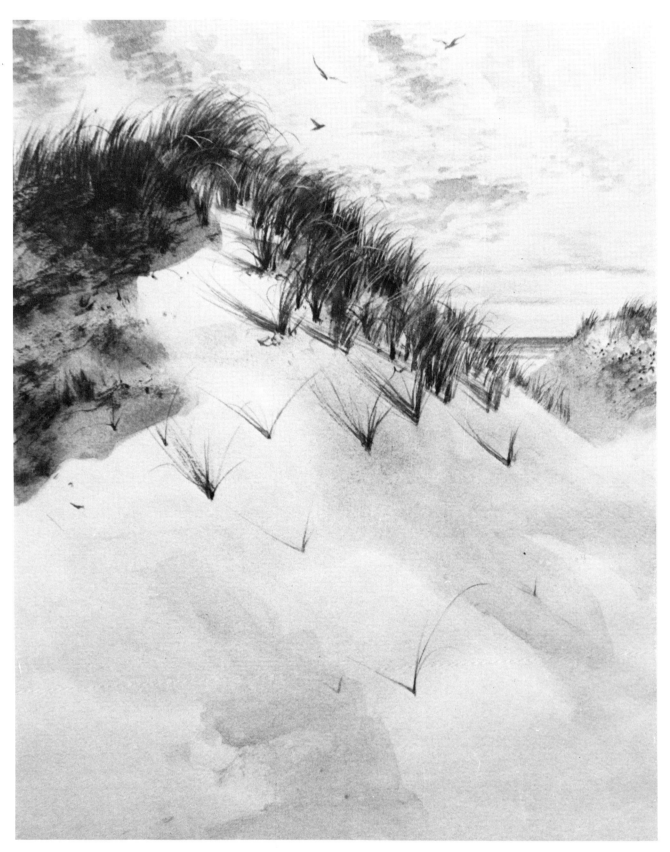

Step 5. When the grass itself is finished, I paint the shadows it casts in deep values to show the strong sunlight bathing the scene. Then, to reinforce the atmosphere, I introduce the gulls, hoping that the spectator will hear their cries and feel an intensified response to the picture.

WATERCOLOR: WET-IN-WET

14

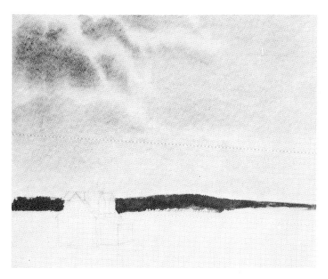

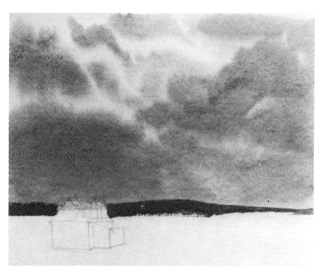

Step 1. I squeeze a ½″ of Van Dyck brown onto a large white plate. Then I wet Morilla paper with the No. 20 flat sable brush. Touching the color with the edge of the brush, I work out a satisfactory tint on the plate for the sky, which I paint while the paper is still wet in order to get the soft edges. The whites showing between the clouds are the paper itself. When the paper dries, I paint the dark horizontal spit of land with a No. 6 brush. With the office pencil I draw the cottage.

Step 2. Slipping a rubber band over the ends of the paper so the wind won't flap them, I wet the entire sky area again with the No. 20 flat sable brush. As you'll see when you do this, the shapes already established aren't disturbed in the least. Then, while the surface is still wet, I render the clouds in their middle value.

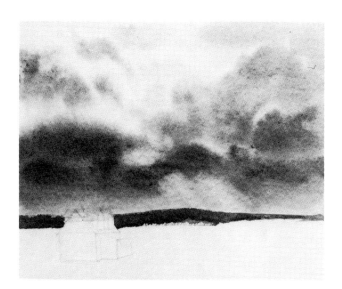

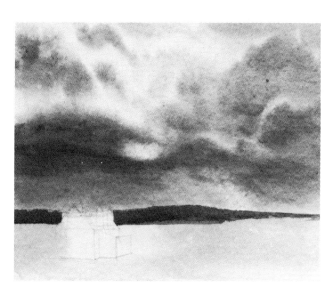

Step 3. When painting in a strong wind, the color dries instantly, so I have to wet the sky once more to accentuate the lower bank of clouds with deeper values. I also add some darker notes at upper left. By the time I finish these shadings—still using the No. 20 flat sable—the paper is dry again. At this point I enlarge the light spot of the sun and its diagonal rays with a kneaded eraser.

Step 4. This is the easiest step of all—I wet the space that's going to be the bay, and with the same No. 20 flat sable I float a light tint, leaving the paper untouched in some areas for the reflection of the sun.

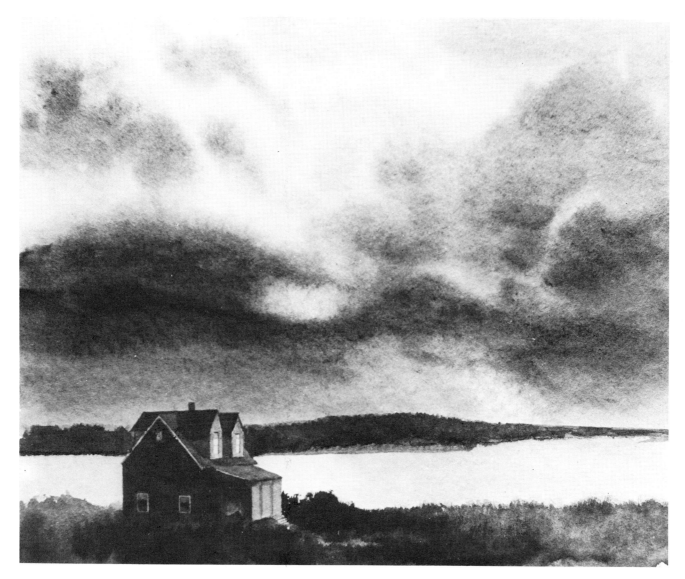

Step 5. Now I'm ready to do the cottage and the near shore. I begin with the cottage, using brushes Nos. 1 and 3 and the Van Dyck brown full strength, as well as diluted for light tints. Then I move to the foreground and, with the side of a No. 6 brush, I render the ground in a middle tone. While it's still wet, I dip into pure pigment and paint the dark passages against the house.

Materials. Paper King pad. Office pencil. Payne's gray. Brushes Nos. 2, 3, and 9.

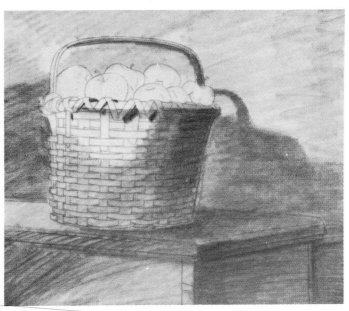

Step 1. Here, I place my first drawing (done on tracing paper) with its linear detail under another piece of tracing paper. Using my draughting pencil, I try several shadow patterns, all with the light coming from the upper left, but none work. (With half the cylindrical form of the basket in the light, the weaving is a bit too persistent and detracts from the apples I want to emphasize.) Using artificial light, I set up a piece of cardboard to cast a shadow on the left side of the basket as well. Success. With the basket mostly in shadow, attention can center on the apples.

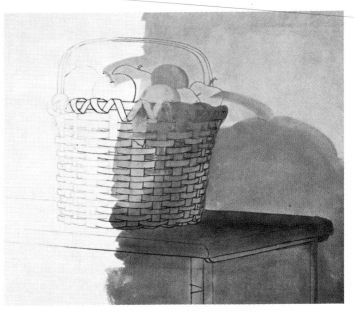

Step 2. Instead of showing several stages separately, I have used one picture to show you pieces of all the various steps. After tracing my line drawing onto the illustration board, I go over it in India ink with the No. 303 pen. When the ink dries I float on thin washes with a No. 20 flat sable. The first washes consist of a diluted mixture of French green, black, and white. For the basket I use yellow ochre, burnt umber, cadmium red light. For the apples the colors are Indian yellow, French green, and burnt umber.

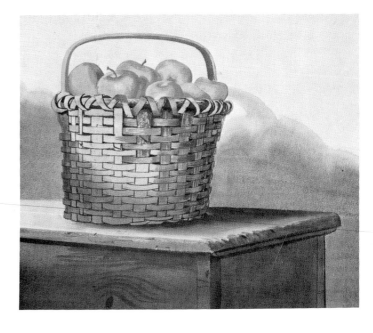

Step 3. Here I've extended my washes all the way to the left edge and completely covered my pen-and-ink line. However, as you see, it still shows clearly through the thin washes of color. Remember to keep your cake opaque colors wet by periodically squeezing a sponge over them. Besides the colors in the Maraba box, I'm using a 2 oz. jar of Artone white. I've started to model the apples, the basket, and the chest with thin paint. I just want to establish their form by decisively separating their light and shadow areas. Later I'll add details, textures, and whatever refinements I need. I've also lightened the background because I need contrast to bring out the apples, which are to be the center of interest.

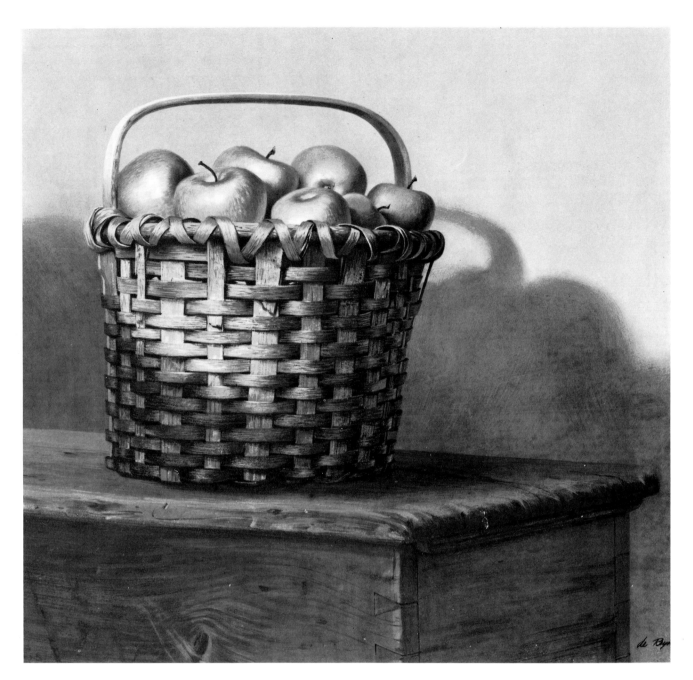

Step 4. The last step pulls the entire picture together. If a value comes off too light, I work a darker tone over it with drybrush. If the value is too cool, I warm it up with yellows. If it's too warm, I try green or umber tempered with white or black or both. I model the apples wet-in-wet and refine edges with a drybrush and very thin pigment. Then I proceed to the minute detail of the weave of the basket and the texture of the old chest. I work smoothly and strive to show the surface qualities and values of a particular area rather than clever brushwork. Just when I think the paint-ing is finished, I notice that the apples are a trifle too cool. So, with the No. 7 brush I float a thin layer of yellow ochre over each apple very lightly so that I don't disturb their definition. This yellow dims the highlights a little, so I go over them again with white.

Materials. Tracing paper. A 33" x 30" piece of rough sur-face illustration board, Superior brand. Nos. 3, 5, 7 water-color brushes. No. 20 flat sable. India ink. Gillott's No. 303 pen.

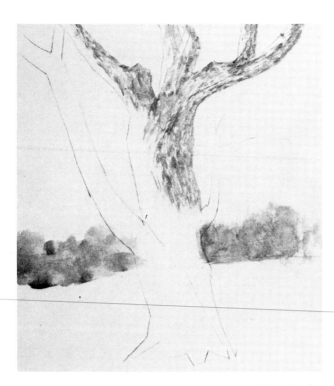

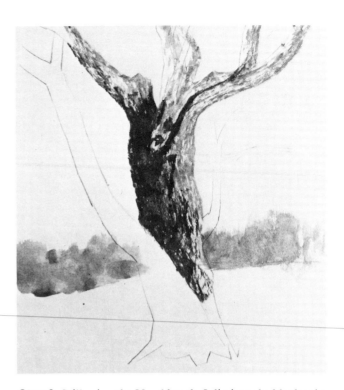

Step 1. First I use a pencil to sketch the tree. Next, I paint the light areas with diluted raw umber and the No. 2 brush. For the texture of the bark I paint with the side of the brush; I use the brush's point to define the edge of the branches. With the same tint diluted on the butcher's tray, I scribble the band of trees in the background using a No. 6 brush.

Step 2. Still using the No. 6 brush, I dip into the black cake of the Pelikan color box, dilute it, mix it with the raw umber on the tray, and begin to shade in the shadow on the trunk. (I'm using the pigment in the consistency of watercolor.) I apply the color in quick strokes so that the surface of the paper contributes to the texture of the bark.

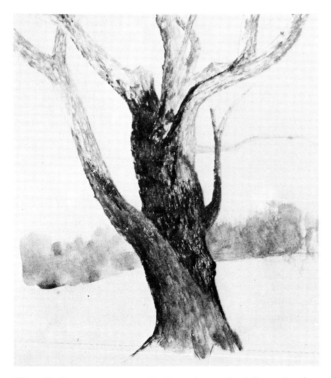

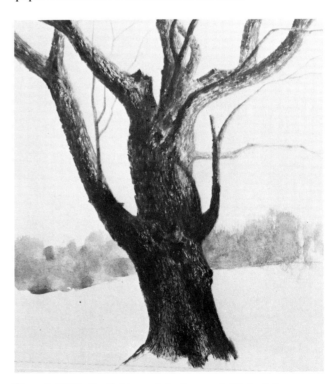

Step 3. I move over to the branch on the left, and using brushes Nos. 2 and 6, I bring it all the way down. Then I paint the vertical branch midway up the trunk on the right, pinning down its cast shadow. Next, I tackle the two branches on the upper central part of the tree because the cast shadows will soon change.

Step 4. With the lights and shadows established, I concentrate on the detail of the bark, with a No. 2 brush. The shadows are no longer the same, but I adjust the tonal values to the light and shadow pattern already set down. The tree is basically done; I proceed with the shoots, the slender branches, and the twigs.

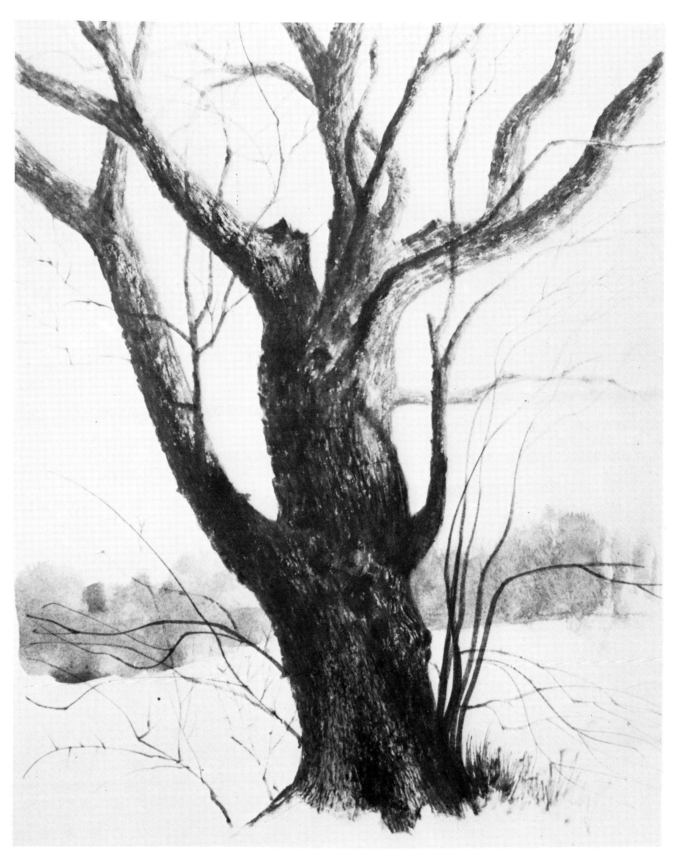

Step 5. With a No. 1 brush, I paint the twigs in quick and resolute strokes. I had intended to render the band of trees broadly indicated in the background, but the sun has set.

Materials. Morilla pad No. 1059-S. Raw umber and black Pelican box colors. Office pencil. Brushes Nos. 1, 2 and 6.

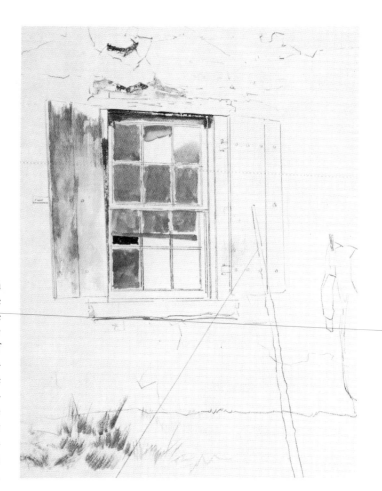

Step 1. After making a watercolor sketch and a sketch on tracing paper to establish the composition, I begin the actual painting with very thin washes that are a mixture of burnt umber, yellow ochre, and black. I want not only to establish facts, but to "feel" the different textures of glass, plaster, wood, and grass. I start with a monochrome of umber and black. To create the blue of the shutters, I will glaze over this with yellow ochre. (Painting *directly* with either blue or yellow ochre won't give the subtleties of color and texture.) Notice I've already established the lightest value (the upper right windowpane) and the darkest one (the value below the shade, on the left). From these two, I will key all the other values.

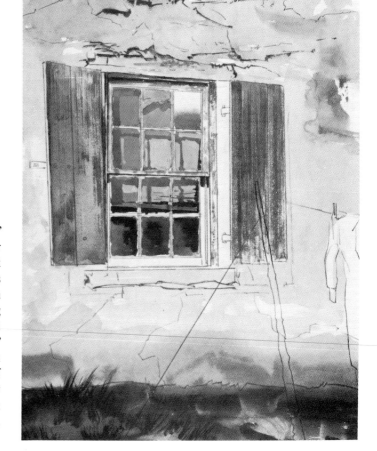

Step 2. Thinking that the window might "swim," unanchored, in the picture, I've made the wall darker than anticipated, but it won't be any trouble to make it lighter. With a No. 3 brush I begin here to indicate its cracks. I glaze the shutters with mostly water and a touch of Winsor blue, using the No. 5 brush. Then, working with the No. 3 brush, I dip into a mixture of blue and white, to which I add a whisper of burnt umber to "age" it. I use this mixture with drybrush to create the worn texture of the wood. I exaggerate the peeling paint of the window frame again with drybrush; I can easily smooth out any areas that become too insistent. When I reach the ground I paint the grass dark against light, as you see, but I change my mind in the next step.

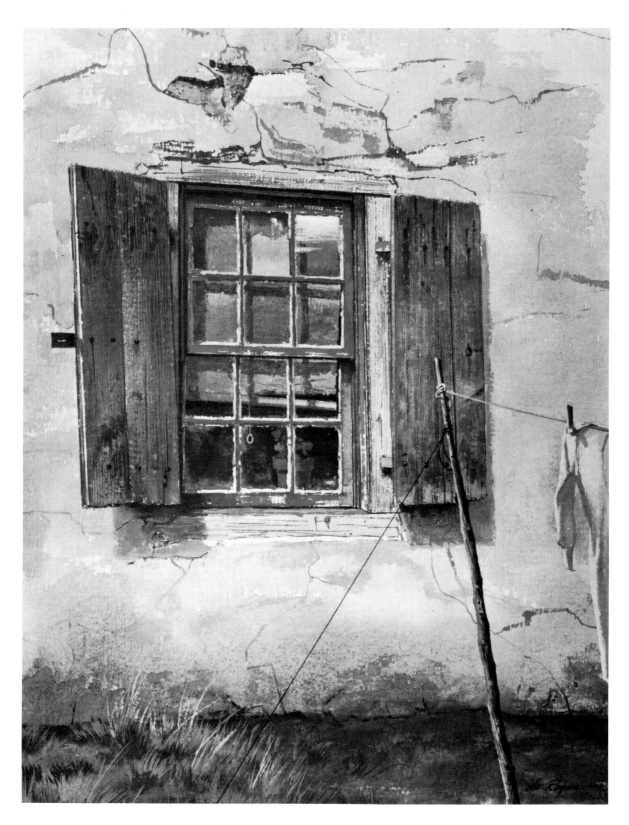

Step 3. An advantage of using opaque watercolor is that if a value turns out to be too dark, it can easily be lightened by adding white. Notice I've made the wall lighter to make the window stand out. I use the No. 20 flat sable brush on the wall, working some of the tonal transitions wet-in-wet. The cracks and the broken plaster are delineated with the No. 3 watercolor brush. After defining the details of the shutters with drybrush and burnt umber and black, I give them another glaze of Winsor blue. Later I again accent some details with drybrush that are subdued too much by the glaze. The color on the ground is the same as the one I used on the original sketch.

Materials. An 11″ x 15″ watercolor pad. Nos. 3, 5, and 7 watercolor brushes and #20 flat sable. Tracing paper. 5H and No. 2 office pencils. Ivory black, white, yellow ochre, burnt umber, Winsor blue and olive green.

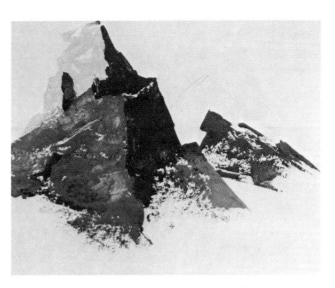

Step 1. With the office pencil I sketch the broadest indication of the two main shapes. Then I take up the painting knife, which has a 2 inch blade and is trowel-shaped. I scoop some No. 5 gray from the jar onto the tray and, without diluting it, I tap the flat of the blade on the pigment. I rotate the blade on the illustration board to get the solid and textured areas—the board itself provides the texture. In effect, I let the knife take over.

Step 2. I scoop up some of the No. 2 gray, flatten it on the tray, and apply it to the light area at the top of the main rock. Then, working my way down, I pick up the No. 4 gray, scraping and scratching with the edge of the blade. As I near the bottom of this light plane, I rotate the flat side of the blade on the board so that some of its texture can show through.

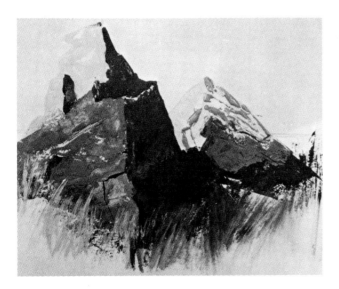

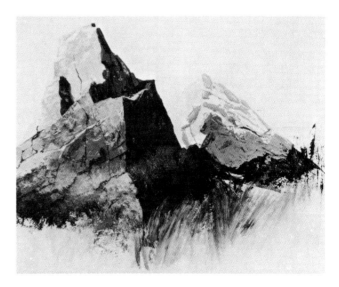

Step 3. Now with Nos. 1 and 3 grays I begin the second rock. I decide to kill the texture done in the previous step when I rotated the knife because that texture conflicts with the grass that's coming up next. Therefore I cover the base of the front panel with black. Continuing with black, I paint the weeds at the extreme right with the edge of the blade. At this stage I've got all I want from the painting knife, so I switch to a sponge to suggest the grass with a No. 2 gray.

Step 4. To finish completely, I concentrate on the foreground rock. With the tip and side of brushes Nos. 1, 2, and 4, and grays Nos. 1, 2, and 3, and black, I begin at the top and work my way down articulating cracks, correcting values, and refining details. Keep in my mind that the texture I achieve now wouldn't be possible without the painting knife groundwork.

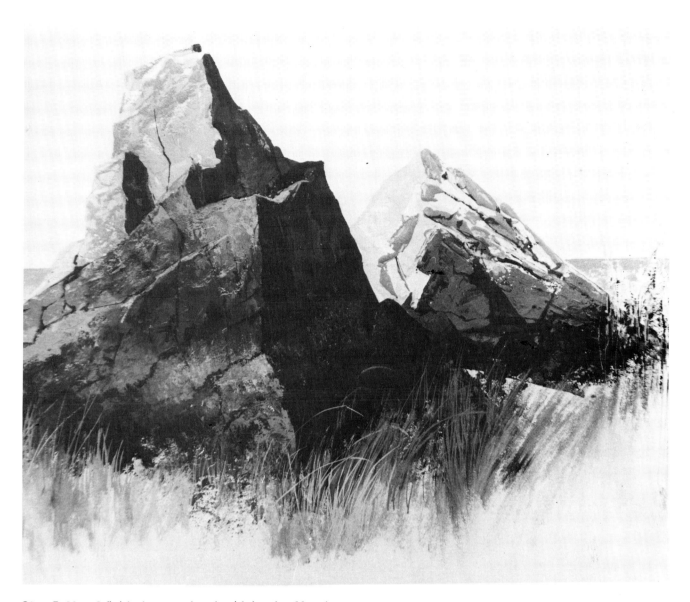

Step 5. Now I finish the second rock with brushes Nos. 1 and 2, and grays Nos. 1, 4, and 5, setting down details that the painting knife couldn't achieve. Next, with Nos. 1, 2, and 4 grays, I finish the grass with the No. 1 brush. Then I pick up a No. 3 gray and add the bay in the background. To finish off, I add the reflected lights with a No. 4 gray in the shadow area of the foreground rock.

Materials. A 2½″ painting knife. No. 80 illustration board. Sponge. Gamma grays and black. Office pencil. Nos. 1, 2, and 4 brushes.

Step 1. After making a sketch on location, I decide later in my studio that an area 14⅜″ x 9⅛″ would suit the subject. I trace my drawing on to a double thickness, cold-pressed Crescent illustration board. The horizontal movement set off by the shape of the stone fence sweeps the viewer's eye out of the picture. To correct this, I sketch a tree from my imagination on tissue paper, which I place over the original drawing; I push the tree behind this fence, and it seems to work. To insure that my line drawing won't be lost as I start applying paint, I go over it with a 404 pen and India ink. When the ink dries, I will float a very thin wash of cerulean blue and yellow ochre acrylic over the entire sky area, using slightly more yellow than blue to preserve the amber glow of the sky.

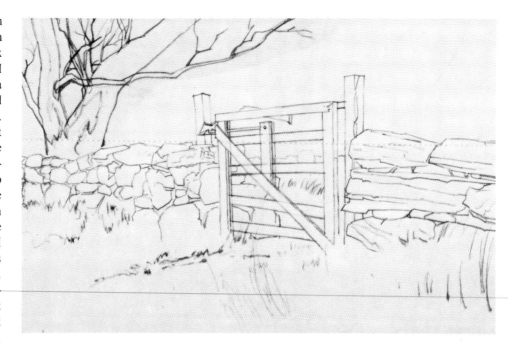

Step 2. If I had painted the sky in an opaque manner, its luminosity would have been lost. To lay in my wash, I turn the drawing upside down. Using horizontal strokes with the No. 20 flat sable brush, I work the wash (previously mixed and then tested on scrap paper for value and color) all the way across from side to side and down to the bottom edge which is the top of the picture. The ink line still shows through. While the sky dries, I turn the board right side up and start applying an impasto on the stone fence with a painting knife, using titanium white acrylic straight from the tube. In about an hour, the impasto is dry enough to begin glazing using a No. 30 flat sable with a thin mixture of raw umber and ultramarine blue.

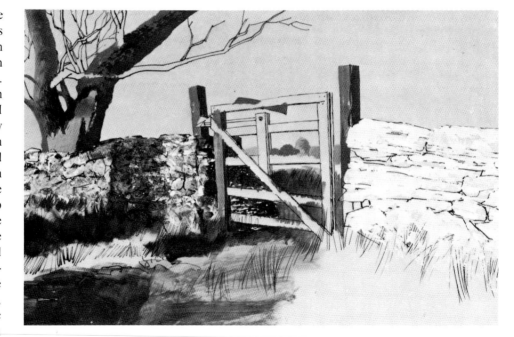

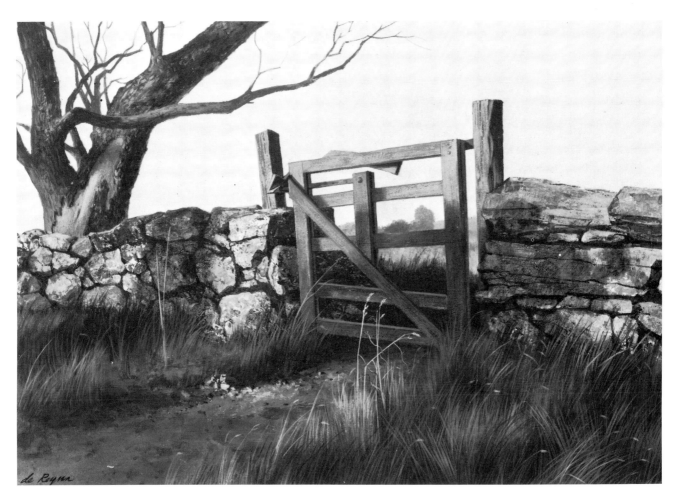

Step 3. By the time I reach this stage, I've prepared the ground for final execution. Following the principle of working from the back forward (doing the objects that are "behind" first), I start finishing the background seen through the gate. Then with the No. 3 and the No. 5 brushes I begin to bring out the character of the tree. Notice in the final painting that I've subdued some of the branches and twigs you see here because I feel this area is a bit too "jittery." After glazing the right-hand portion of the stone fence, I begin to scumble the left section with the No. 5 brush. I paint the gate in flat color without values. In the final step I'll add to it with drybrush which will weather the wood.

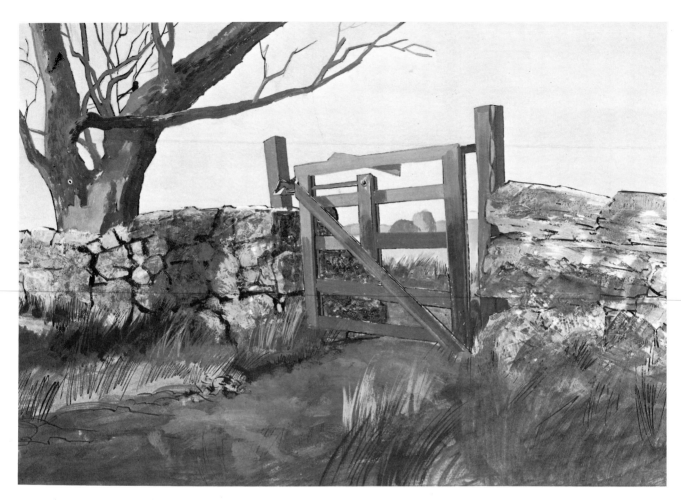

Step 4. Now I begin the definition of edges: soft on the background and foreground grass and hard on the fence and stones. I delineate texture on the bark of the trees and wooden gate using the drybrush technique. I keep the lights warm and the shadows cool. While deepening a shadow or the contour of a stone, I modify, if needed, the lighter area adjacent to it. You can do this easily using acrylic because it dries so quickly. I keep shifting from one area to another trying to carry the entire picture forward at about the same degree of completion but not really putting the last touches anywhere. With ultramarine blue, raw umber, and black I work on the cast shadows on the grass and the fence. Finally, with yellow ochre, I articulate the grass with upward sweeps of the No. 3 pointed brush.

Materials. Illustration board. 5H, 2B and 4B pencils. Nos. 3, 5, 7 watercolor brushes and No. 20 flat sable brush. Painting knife. Mars black, titanium white, raw umber, yellow ochre and ultramarine blue acrylic paints.

Step 1. After making a sketch in opaque water-color, I prepared my board with a coat of white casein. Armed with the color sketch and a careful pencil rendering (which I haven't shown here) I'm ready to rearrange, if necessary, and compose the final painting. The main shapes are traced to the chipboard. I transfer only the big divisions to my chipboard, because I'm going to develop the rock formations mostly with my painting knife, and I'll only add detail to it in the last stages.

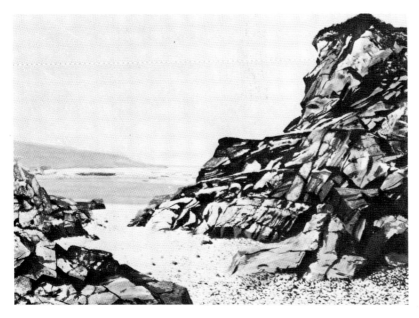

Step 2. Here I paint the grass at the top of the cliff, as well as the distance and the pebbles on the ground, with acrylic that has a regular brushing consistency. For the rocks I use a thick gray impasto mixed from acrylic titanium white and Mars black. I apply this impasto with my painting knife. The texture is the main thing I'm after here. To avoid monotony of texture, I pat with the knife, scrape hard with its edge, and then drag it lightly with its blade flat against the painting surface.

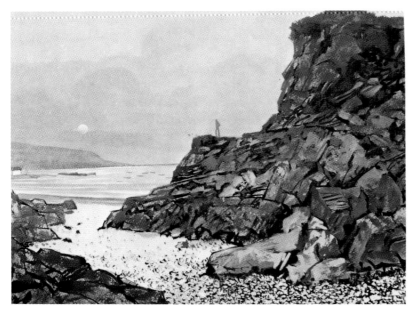

Step 3. To create the soft hazy effect of fog, I now work wet-in-wet and use the No. 7 water-color brush. I paint quickly so I can blend one tone softly into the other. I use mixtures of white and yellow ochre, and also mixtures of cerulean blue, white, and black—with a whisper of acra red—to create the necessary cool and warm grays of the fog. Here I also introduce the figure I had in the original sketch to give the picture scale. Still using the No. 7 brush, I cover the rock formations with a thin film of white, blue, and acra red acrylic. The pervading color on the rocks becomes a gray-mauve because of the "veil of color" that I glaze over the black and white underpainting I did in Step 2.

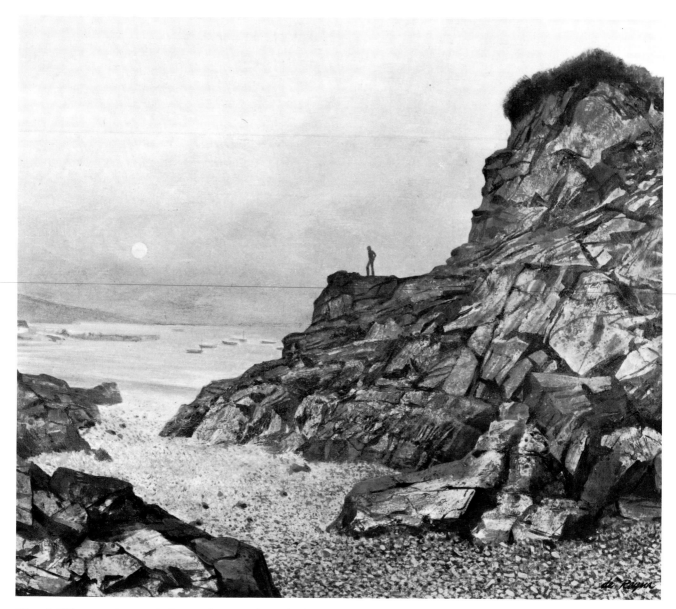

Step 4. What remains now is dessert. I go over the entire sky, using thicker pigment. I blend the edges of the sky wet-in-wet with the No. 7 brush to create more softness. Then I subdue the color on the swells and on anchored boats to make both very close in hue, so that they're hardly visible through the fog. The effect I'm striving for is a hazy and indefinite one in soft pearly tones. Check for yourself to see how fog or rain mutes local colors and throws a "veil" over the scene.

Materials. Chipboard. White casein primer. Brushes. Painting knife. Acra red, yellow ochre, cerulean blue, Mars black and titanium white acrylic paints.

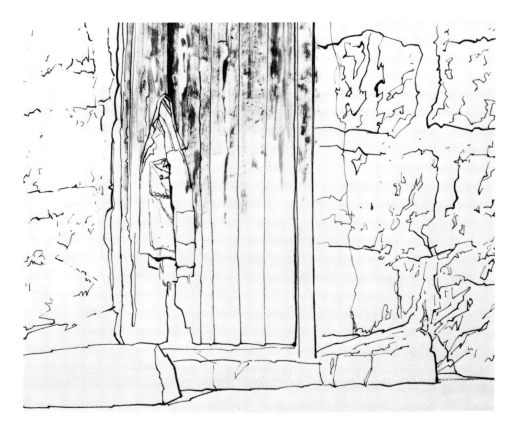

Step 1. I tape my drawing (done on an Ad Art, 11″ x 14″ sheet of paper) at the top of an 11″ x 14″ piece of illustration board. Then I trace only the most important lines and configurations onto the illustration board. With the main shapes traced, I reinforce them with India ink using 404 Gillott pen. I do this to be sure the line drawing won't be obscured by the impasto and drybrush that's to follow. Now I pick up acrylic titanium white with the underside of my painting knife and apply it thickly to create an impasto following the configurations of the wall. This impasto gives the walls their rough texture. Then, with a "fanned" No. 4 watercolor brush, I begin the texture on the door with drybrush.

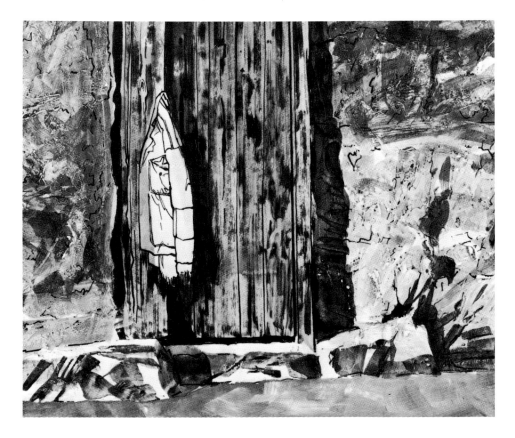

Step 2. After the impasto dries (usually not less than an hour, since it's such a thick application of paint). I begin to glaze it with a mixture of black and raw umber in about equal proportions with a large amount of water, so that the glaze goes on as transparent film. I apply the glaze with a No. 20 flat sable brush. As I apply the glaze to a small area, say two or three of the stones, I rub it with my finger while it is still wet to bring out the light areas in the upper left corner. Notice that I carry the drybrush and glazing slightly into the coat, so that when I paint the coat later, it won't appear to be cut out and pasted on top of the door.

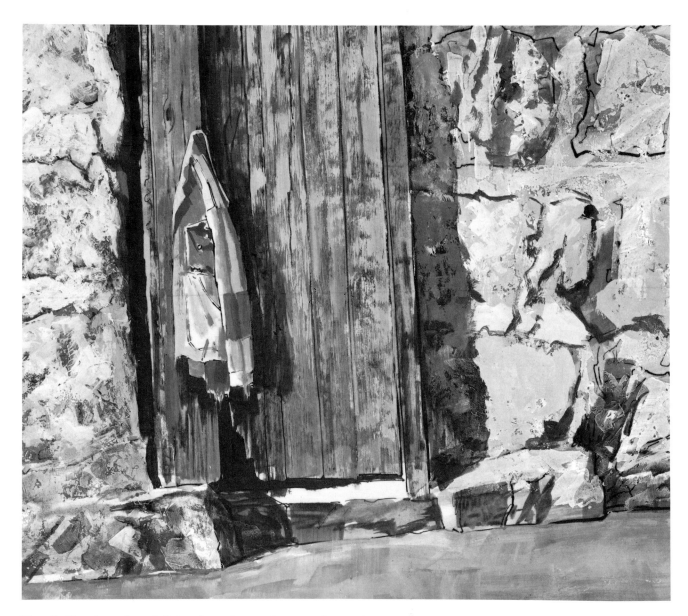

Step 3. Here I continue defining the wall, stone by stone. I also work on the door. When I'm ready to paint Joe's coat, I hang it in the studio and throw a light on it that's consistent with the angle of the light in my original drawing. I go over the woodwork with a drybrush (and a No. 3 sable) but this time I use light pigment over the already dark, glazed surface. Where the dark grain of the wood gets obscured, I immediately rub off the light pigment with my finger to let it show through. In some areas I go over the woodwork again using a thin gray composed of raw umber and black. I even use pure black on some of the knots and cracks between the boards. Finally, I add ultramarine blue to the umber and render the coat with a wet-in-wet technique to simulate its soft folds and limp cloth. These qualities provide a contrast to the firm textures of the door behind the jacket.

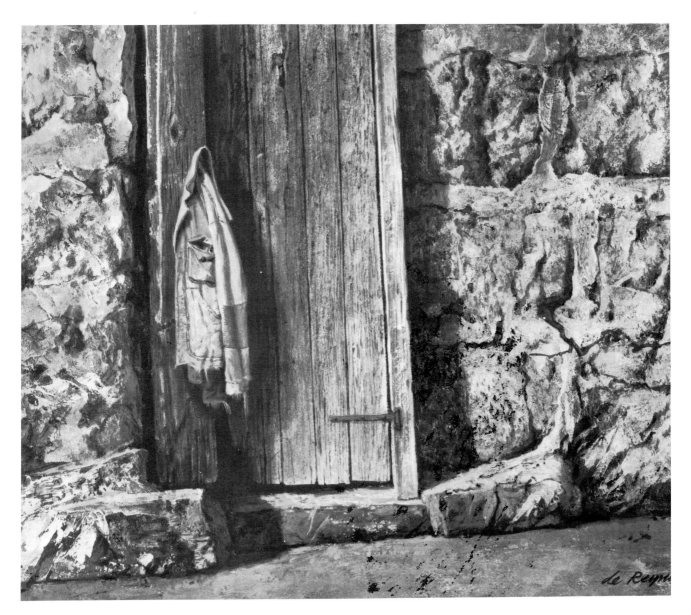

Step 4. The main thing I want to stress in this final step is that I've suppressed brushwork as much as possible, and given the object itself paramount importance. This is the approach I've taken in every one of the projects, no matter what the subject, since my intention is to capture the "realism" of the motif itself and not to display any brushwork pyro-technics. Even though I've used several techniques in this painting— wet-in-wet, impasto, drybrush and even my finger—they must all convey the form, texture, and color of the subject matter, not draw attention to themselves. The last things I do here are the textures on the ground which I scumble in. The fine threads on the frayed sleeves, the stitches on the patch, and the hinge on the door I delineate with my pointed No. 3 sable.

Materials. Nos. 3, 4 pointed sable brushes. No. 20 flat sable brush. Double thickness, medium surface, 11" x 14" illustration board. Black India ink. No. 404 Gillott pen and holder. Acrylic colors: Mars black, titanium white, raw umber and ultramarine blue. Drawing pad. Tracing paper. No. 314 draughting pencil.

I chose this simple subject to buttress your confidence, should it be wobbly, and to entice you to begin painting straight away. I also want to show you that even the most basic handling of transparent watercolor can achieve an impressive realism. You can, if you wish, copy these onions if only to increase your skill in the medium, but you can also set up a different arrangement so that you can lay claim to your own creation! Use a pair of old shoes or a head of lettuce. Just be sure to use fundamental techniques: flat washes, graded washes, wiping out lights, drybrush, and scratching out lines with a razor blade.

Use the brush that will help you to paint a particular passage with facility and dispatch. I chose a Simmons No. 6 White Sable pointed brush for the initial flat and graded washes. I also used a razor blade to scratch out the light lines of the roots.

Because these onions are predominantly red-violet, that mixture was used most. It was also tempered, however, with the yellows, oranges, greens, and browns found in Grumbacher Symphonic watercolor set No. 30/17.

I chose a Bainbridge No. 80 cold pressed, single thickness illustration board. Just as it is important to pick the correct brush for a given job, it is also important to select the right surface. The eggshell surface of this board, for example, makes it easy to render the dry brush passages. It also takes flat and graded washes smoothly. This paper is also sturdy enough to withstand the punishment of the razor blade.

At the beginning of the last century, a watercolor was done with powdered pigment, a spot of glue to bind it, water to thin it, and that was all. Today, a watercolor can be a potpourri of transparent and opaque, interlaced with crayons, inks, and pastels— seasoned with a sprinkling of salt, and even battered with a few swishes of sand. And why not if the desired results are obtained? But this demonstration shows you that the medium itself can do without the aid of other materials. Later you will tackle and combine transparent watercolor with other media.

Painting Tips. The larger the painting the thicker the support, is a good rule to remember when working in watercolor. Anything larger than, say, 11″ x 14″ should be done on double thick boards to prevent bending and buckling. A realistic painting, unassisted by lucky accidents, can take a day, a week, and even a month. So protect your color between sessions. Put the lid back on the painting set. Rinse brushes well with mild soap. And reshape them by pulling the brush between your fingers to its original shape. The dry color on the palette can be used the next day by spraying it with an atomizer before beginning to work—or simply by rewetting the brush with whatever color you need. If you intend to be absent longer, then cover the entire palette with plastic film so it doesn't get dusty.

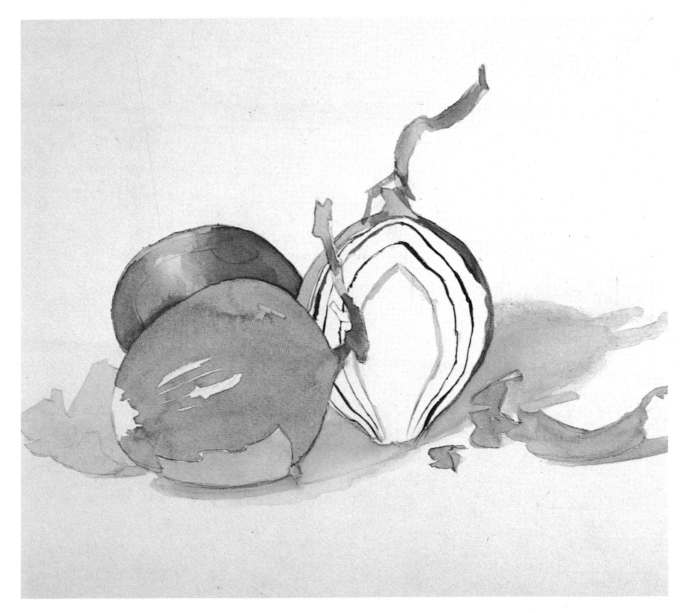

Step 1. After transferring the preliminary drawing to the illustration board, I use the No. 6 White Sable watercolor brush to float a thin flat wash of red-violet over the front onion. Notice the saved white areas that I left, which will become the highlights. I move then to the cut onion and, with the tip of the brush, I indicate the contour of the bulb as well as the divisions of the core. Next, I pick up paint from the puddle in the butcher's tray, which is mostly water with a touch of red-violet from the Symphonic set. With the brush I transfer some of this puddle to another spot on the tray and add a bit of orange to it. I wet the rear left onion with clear water, and then apply the graded wash to the left side and then to the right side, letting the pigment skirt the highlight in the middle. As I do this, I tilt the illustration board to an angle that lets me control the shapes of the washes. After adding more water to the second puddle, I paint the skins falling off the front left onion, and also those on the right. Now, to do the stems I mix as I paint, as opposed to using a premixed tint, and dip into the brown light, yellow-green, and yellow ochre. Finally, after dampening the area, I do the cast shadows with blue-violet and brown dark.

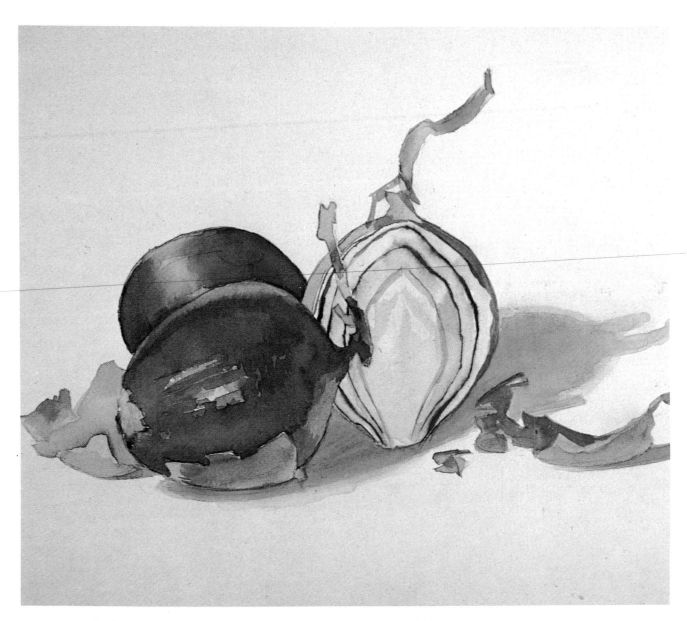

Step 2. I give the front onion another deeper wash of red and red-violet, avoiding the white highlight and leaving the top light and the reflected light, at lower right, untouched. Then I dampen the rear onion again, and float the graded washes (red-violet with a bit of orange) with a mixture of red-violet and brown light. Be sure to tilt the board to whatever angle is necessary to control the flow of the wash and to create the required shapes. Next, with clear water on the brush, I brush back and forth across the lines on the core of the cut onion to blur the divisions while tinting the whites at the same time. (I have placed the onions right before me to check colors and values as I proceed.) Then, with yellow and yellow-green very much diluted I tint the heart of the core. I move to the skins that have fallen off and begin defining them with red-violet and brown light. Not worrying about details yet, but carrying the big shapes forward at the same clip, I deepen the cast shadows with blue-violet and brown light.

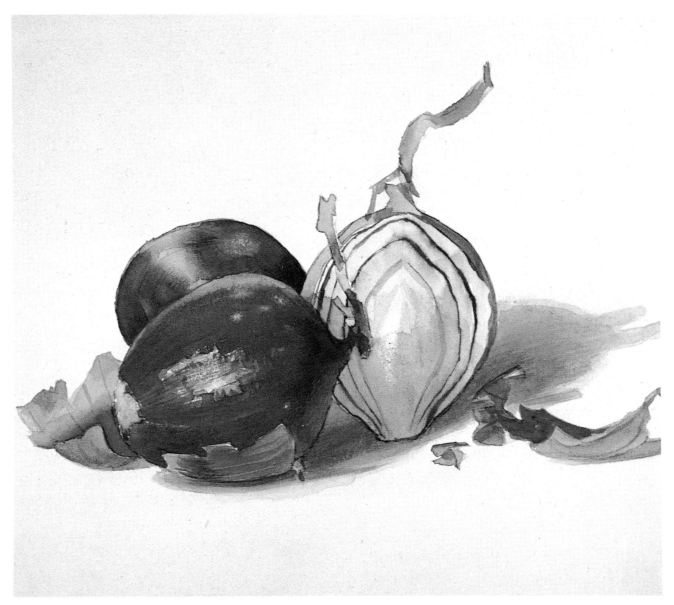

Step 3. I deepen the darks on the skins with red-violet, blue-violet, and brown light, and begin considering their detail. Before proceeding with the modeling of the front onion, I enlarge its highlight with the corner and the edge of the razor blade. Still working on the front onion, I dampen the area with the brush and while still damp I strengthen the form with deeper tones of red and red-violet. I render the light specks on the front onion using a brush charged with clear water, mak-

ing sure that the board is level so the beads of water won't run. Then I pick up the dissolved pigment with the brush dry, and press a piece of paper towel to each spot before proceeding to the next one, to avoid leaving watermarks. Next, to paint the cast shadow on the core of the cut onion, I mix red-violet, blue-violet, and yellow-green. And last, I deepen the cast shadow areas under the onions by drybrushing a mixture of red-violet, blue-violet, and a touch of brown light.

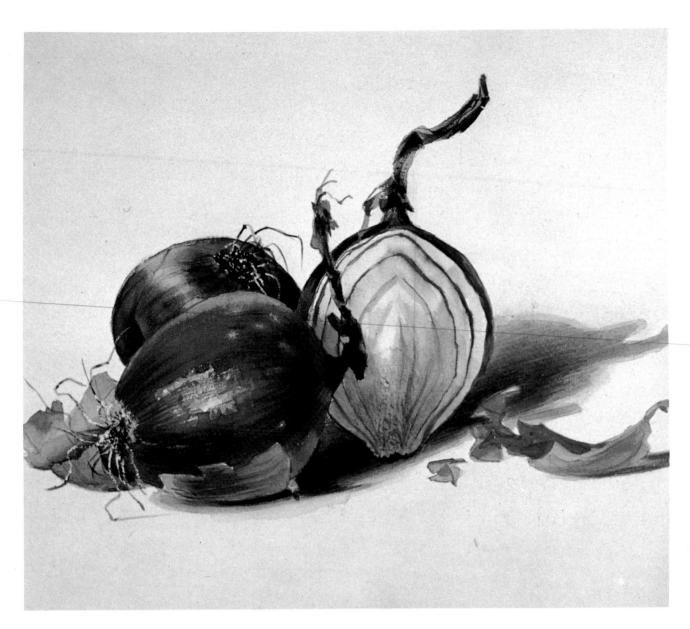

Step 4. Now for the details. To do the base of the roots of both the front and rear onions, I just dip into the dark puddles I used for the skins and shadows that are already on the tray. Then I give the base of the roots a few pecks with the corner of the blade to get their texture. Still using the corner of the blade, I scratch the roots and extend them over the light background and base with a tint of very diluted brown dark and yellow-green. With these same colors I move on to the stems and give them their final touches. As you see, there are no secrets in transparent watercolor; it's only a matter of following logical, consecutive stages—the first ones preparing the ground for those that follow. Once you've done this simple watercolor, or one of your own subject, employing these fundamentals, as your skill develops you'll be ready to tackle progressively more complex subjects.

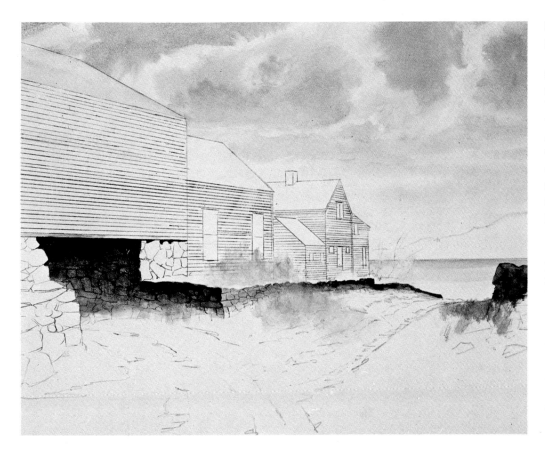

Step 1. After transferring my drawing to the Bainbridge board No. 80, I dilute the blue II of the Brilliant watercolor box No. 30-25 on the tray, and add a whisper of brown light and water. I wet the edges of the picture I want soft with a No. 7 brush and apply the color so it spreads. Then I add more water and a touch of yellow ochre to the paint and, wetting the required edges, I do the lower part of the sky. When this dries I wet the contour of the cloud at upper left and apply a mixture of Payne's gray and brown light. I work my way to the right, diluting the color for the lighter passages.

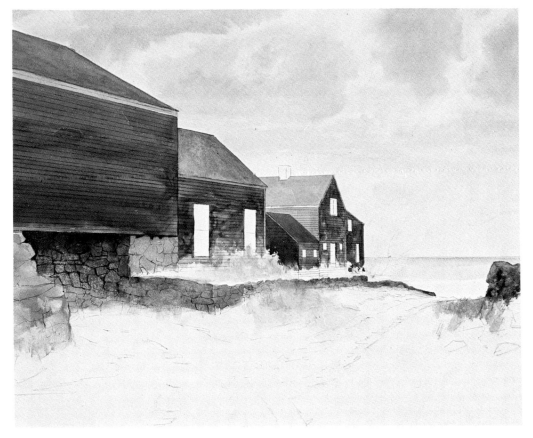

Step 2. I apply a mixture of Payne's gray and brown light to the buildings with a No. 5 and No. 7 brush, trying not to float an even tone because I want the blotchy and weathered effect from the very beginning. As I lay down this large dark area, I keep an eye on how it balances the light ones already established in the sky. Next I remove the line of the hill jutting out from the right with a kneaded eraser because it's too high. Modifying and rearranging elements to create a verisimilar pictorial statement gives you the greatest freedom to invent a scene which, although existing nowhere, can still delight the spectator.

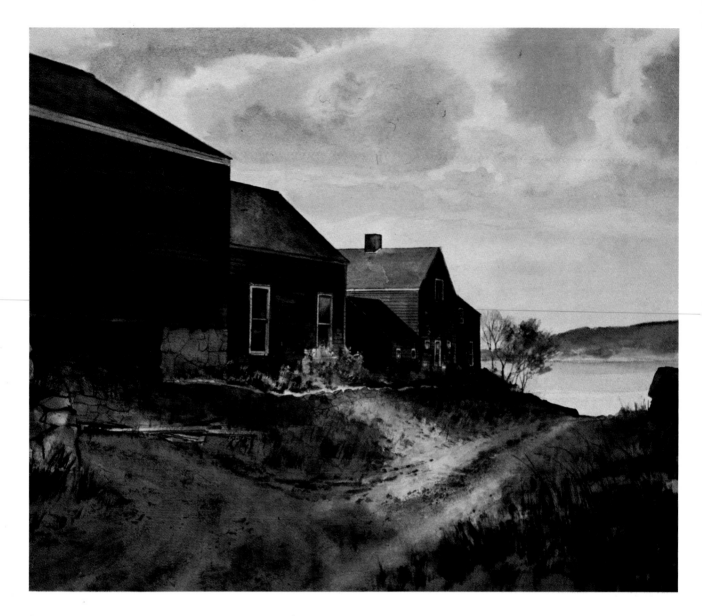

Step 3. Applying the same color mixture used for the buildings, I paint the grass and the road configurations using the point, side, and heel of a No. 3 brush. Then I tap a synthetic sponge between the wheel marks for still more texture. This is followed by large washes with a No. 9 brush over the entire ground, letting the Payne's gray or the brown light dominate for cool or warm nuances. With the same mixture but adding more water, I do the hill in the distance. Then I move to the chimney and paint it with mostly the brown, tempered with the gray. Next, with a scantily charged No. 2 brush I paint the foliage on the tree and indicate broadly the bushes under the window. The picture at this stage is complete, even if unfinished. Many artists would stop here because the desired effect has been captured, but what moves me to paint is both a need to seize a mood and to loot as much of nature's beautiful detail as I possibly can.

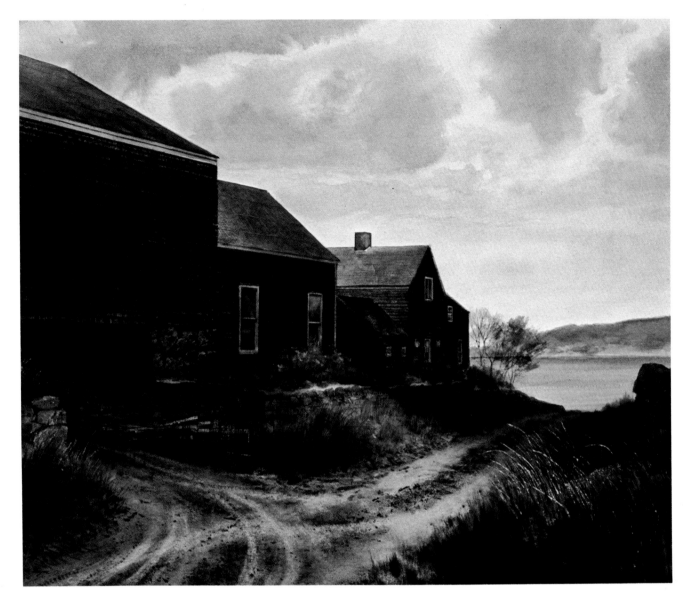

Step 4. I scratch the lights on the shingles with the entire edge of the razor blade, exposing the bare board somewhat—I can dim these marks later with a wash. Next, with a No. 1 brush I do the vertical separations of the shingles, applying a full-strength mixture of the gray and the brown. I also reinforce the horizontal lines wherever the razor blade lightened them too much. Dipping into the green with a No. 5 brush, I drybrush the blotches on the barn, the adjoining structure, and the house. I then continue deepening and defining shape and texture on the walls, the road, and the grass. When I carry everything to the depth of value I want, I use a frisket knife to scratch in the light blades of grass, and an ink eraser to pick up the wheel marks on the road. Moving over to the roofs, I lighten portions with a kneaded eraser; this gives them a more interesting gradation. Now that I've recorded the mechanics of the painting, I'd like you to study the interplay of hard and soft edges: the combination of straight and playful lines is, to me, most appealing. Just one more thing: notice that I didn't use even a drop of white pigment in this painting. You can use white if you have to, of course, for minor corrections or for a tiny light detail over a dark passage—but it's a challenge to try not to.

WATERCOLOR: COASTAL SCENE

Step 1. With a 5H pencil I trace only the contours of the elements from my preliminary sketch onto the d'Arches 140-pound rough watercolor block. Then, I apply the Luma liquid mask with an old No. 5 watercolor brush. I work the masking well into the contours and solidly cover the thin and narrow shapes so that when the background is done I won't have to worry about slipping over into the main subject. I work as quickly as possible but even so the masking begins to accumulate round the ferrule of the brush. So, after rinsing the brush vigorously in water, I pull off the stuff with my fingers before continuing. (Remember to use old brushes.)

Materials. Brushes: No. 22 flat sable, (00), pointed watercolor brushes Nos. 3, 8, 10; bristle brights Nos. 4 and 6; and No. 6 Simmons pointed white sable. Luma liquid masking. Razor blade. 24″ ruler. Paper towels. Winsor & Newton cadmium scarlet, alizarin crimson, burnt sienna, burnt umber, sepia, New gamboge, Hooker's green deep, cobalt blue, Payne's gray and Davy's gray. d'Arches 140 pound rough.

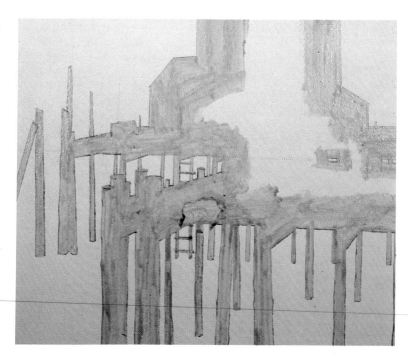

Step 2. Resting the top of the block of paper on the drawing table (at an angle of about 45 degrees), and holding the bottom of the paper in my left hand so that it lies almost flat, I begin wetting the sky area with a No. 10 pointed watercolor brush. The picture measures 13⅜″ x 16⅝″. Then, on the wet surface and using the same brush, I float the clouds with a mixture of burnt sienna, Davy's gray, and Payne's gray, letting the warm Davy's gray dominate. I tilt the block of paper to control the shapes of the clouds, and if a light shape begins to close up I immediately widen it with a damp No. 8 brush. After the sky has dried, I wet the water area. While still damp I take a No. 22 flat sable and apply a graded wash, lighter at the top, using the same sky mixture, but this time I let the cool Payne's gray dominate the other two.

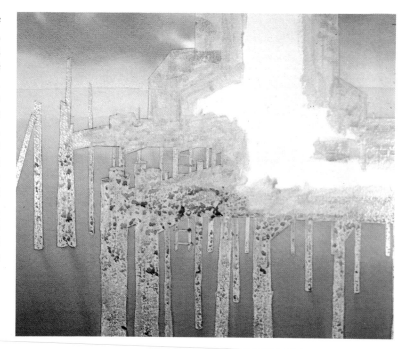

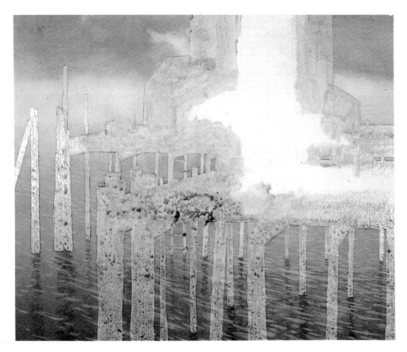

Step 3. When the graded wash dries I dip a No. 4 bristle bright in clear water and rub the shapes of the ripples to dissolve the pigment; I wait a few moments and then mop them up with a paper towel. This is done shape by shape because the lift-offs should be mopped while the water still glistens. As I define the ripples, I refer to an Instamatic snapshot of water just like this. I knew that some day I'd need some information. (Do not attempt scrubbing off any lights except on first-rate paper like this one.) When I finish the ripples I wet and rub the horizon—above and below—with a No. 6 bristle bright and mop it with a paper towel to lighten it more. I want the horizon lost between the sky and the water. Then I paint the stanchions' reflections on the water using deeper shades of burnt sienna, Davy's gray, and Payne's gray. Then I step back and study what I have done; I don't want to touch the background after the cement is removed. Next, using the No. 22 flat sable in horizontal strokes from top to bottom, I warm up the whole thing with a very light glaze of New gamboge. I rewet the horizon and mop it dry with a paper towel.

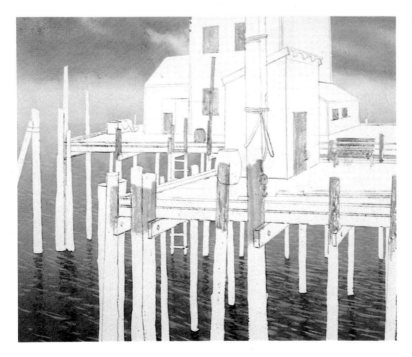

Step 4. After removing the masking with a rubber cement pickup, I rub the lights on the clouds with a kneaded eraser to make them still lighter. Then, I replace the drawing from Step 1 and tape it in position to trace the detail within the contours. Next, I mask the various things that I intend to keep light or brilliant in color as well as the vertical elements over a horizontal plane, like the stanchions against the docks. Note the left edge of the tall building where the paint crept under the masking. Not to worry; I deliberately left it to show you how easily it can be scraped off. There are many other light details against dark areas, but they need no masking because they're small enough to be scratched out with the razor blade after applying the tones.

Step 5. Now I squeeze dabs of sepia, burnt umber, Hooker's green dark, and cobalt blue in the nesting dishes. Using pointed watercolor brushes, No. 8 for the big shapes, No. 6 for the roofs and the door, and No. 3 for the stanchions, I begin painting from the background to foreground and float the dark tones that are mixed on the butcher's tray. When I notice an area that turns out too cool, I drop a little sepia or umber into the wash to warm it up. By the same token, if too warm, I drop blue into the wash. The block of paper lies almost flat when doing this so the color won't run down. The purpose is to liven up the tones with variegations of cool and warm color separately introduced, instead of a pre-mixture that would be flat and dead. I'm using the ruling method for all the straight edges on the building. I dip into the puddles on the tray and dilute the color with a No. 8 brush, then I apply it in quick strokes to the side of the wharf to begin the desired textural effect. After recharging the brush I float the same tone on the deck.

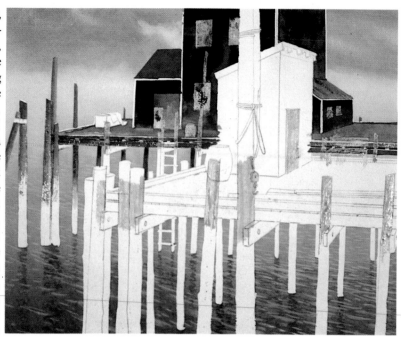

Step 6. With a razor blade I clean up the left and right edges of the building, and then continue with the big shapes after removing all the masking. I'm not thinking of any details yet, I'm pulling the picture together with the right tones and color values. With the No. 8 pointed brush I add more burnt umber, cobalt blue, and Hooker's green dark to the puddle on the tray, and apply the almost black tone to the front shack. Then with a No. 6 brush, I dilute the color to do its top and the corner slats. Next, I paint the top of the stanchions and the understructure of the wharf. (The top and the side were done before I picked up the masking.) With the same color, I paint the barrels, ladder, gear box in the distance, changing brushes from a No. 8 to a No. 6 and a No. 3 to a No. 2 as the sizes of the elements vary. Next I give the posts their first green underpainting of lichen with the No. 6 brush, by squeezing a dab of New gamboge and mixing it with Hooker's green dark as I go along. With the same brush I apply notes of cadmium scarlet to the door and windows. I will subdue them later.

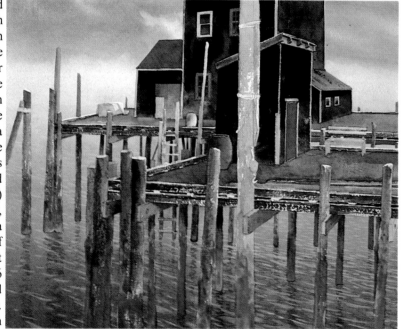

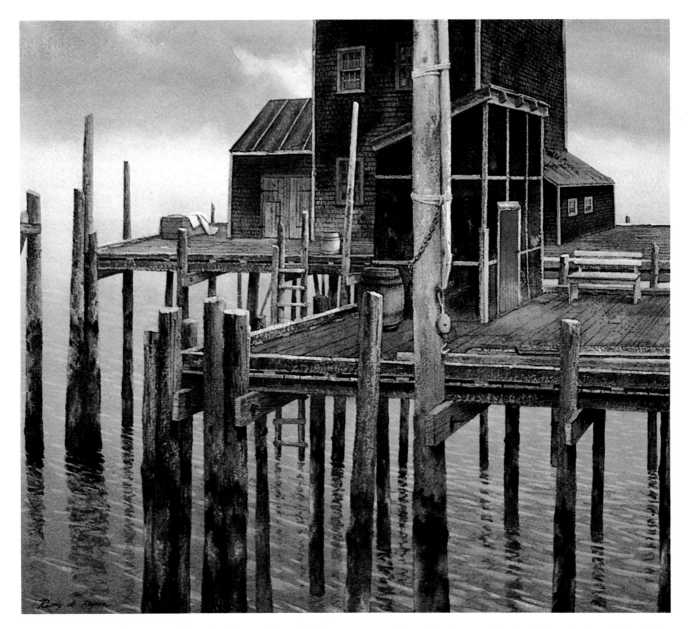

Step 7. I begin details by scratching the slats on the roof with the corner of the blade, and then I rub and lighten the middle section of the roofing paper with an office pencil eraser. Next, using the No. 6 brush, I lower the intensity of the red door and the two windows with several glazes of Hooker's green dark. In transparent watercolor it's easy to subdue a brilliant passage but very difficult to regain it. After wetting the lower part of the door I mop the color off with a paper towel. For the lichen on the posts, I use the No. 6 with a mixture of Hooker's green dark and sepia, adding raw umber to render the dark blotches. Then I subdue the textures on the side of the wharves with thin washes of the original colors, and I

scratch out the slats on the shack. I go back to the building and paint in the shingles with a No. 2 brush, rubbing a No. 3 flat sable across them if they get too distinct. With a small brush, I put in the hinges and other details on the left-hand large doors; then I do the bolts on the stanchions, the hoops on the barrels, the gear box in the distance, and the lumber on the deck in the foreground. Next, I touch up the white bench, add a touch of green and sepia to the slats on the shack, refine the little windows in the back—and that's it. All this without adding any new color; there are enough puddles on the tray to get any shade or tint I want.

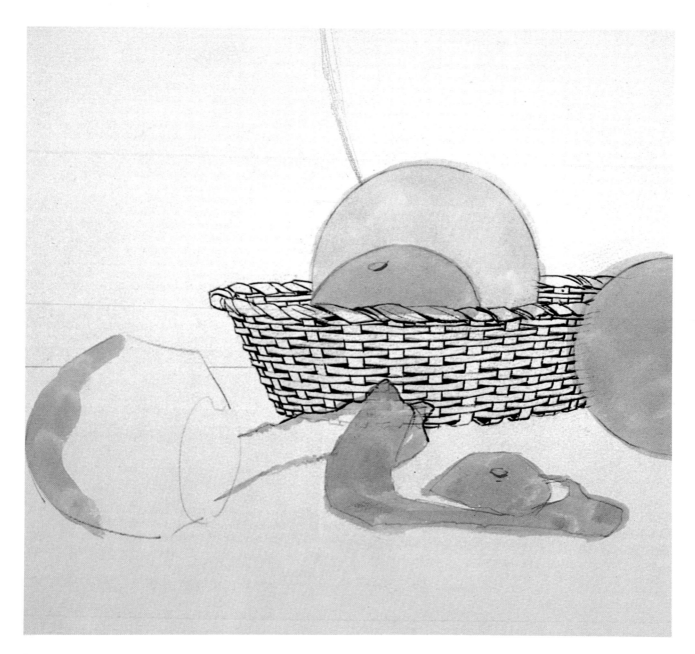

Step 1. After making my preliminary painting and sketch which is traced on to the watercolor board, I use a No. 1 watercolor brush and Winsor & Newton India ink to reinforce the traced lines on the basket. I do this so I won't lose the drawing when I begin applying the opaque watercolor, even in the thin consistency I'm going to use. Next, using lemon from the Pelikan box with a No. 6 bristle bright, I paint the flat middle value of the grapefruit. Then I dip into the orange pan to render the oranges and the peel. I'm painting slightly past the contours of the fruit because it's better to trim back later with the contiguous color than to leave white paper lines between one object and another.

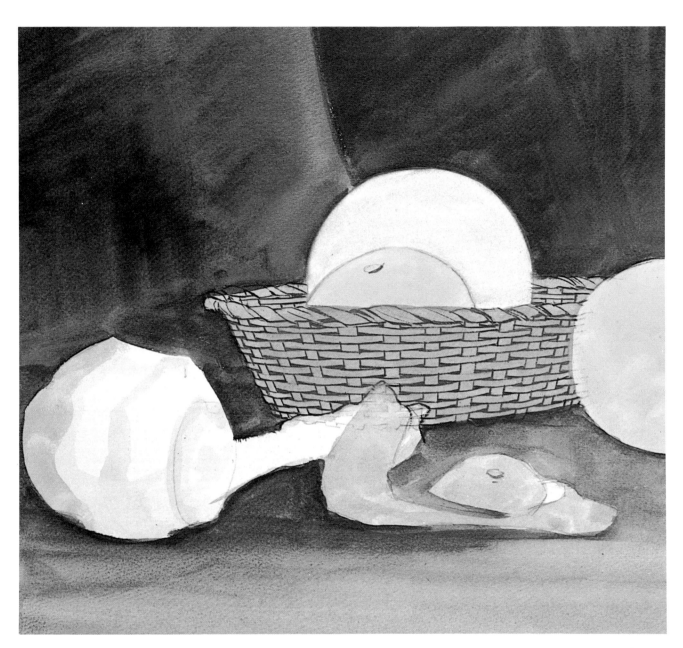

Step 2. With the same No. 6 bristle bright, I render the basket by dipping into yellow ochre, with touches of burnt sienna and raw umber for the thin layer of paint I apply. Note the paint is so thin that the underdrawing in ink is clearly visible. Then I move to the background with the same brush but using black, ultramarine blue, and violet, plus a touch of raw umber, stirring the mixtures on the butcher's tray. For the soft transition to the table, I add orange and burnt umber to these tones. The only hint of tone gradation so far is in the background and on the table. The rest of the elements are painted in flat middle tones of their local color.

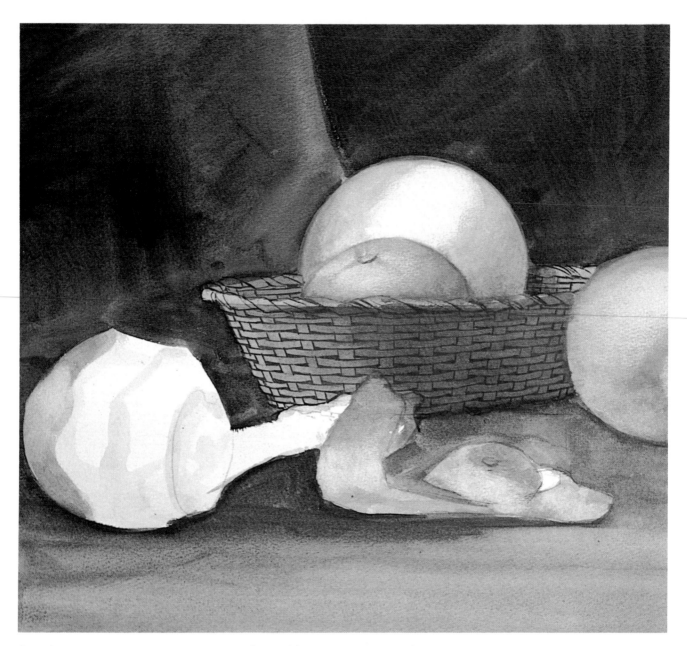

Step 3. With a No. 5 watercolor brush I begin shading the oranges to bring out their form, by adding violet, vermilion, and French green to the original orange color. The grapefruit comes next, and with the same brush, I dip into Prussian blue, alizarin crimson, and the lemon used for its flat local color. The shadow on the basket consists of the original mixture (yellow ochre and burnt sienna) plus ultramarine blue and violet—and a touch of the orange color as the shading nears the orange on the right. Now I further emphasize the lights on the oranges and the grapefruit by wetting the respective areas with a No. 6 bristle bright and removing most of the pigment with a folded paper towel—just as we did when working in transparent watercolor.

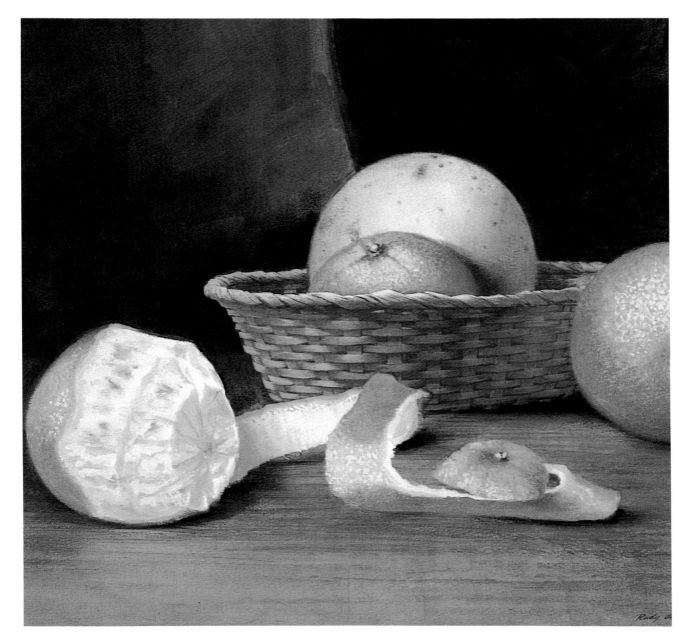

Step 4. After tapping a wet sponge on the grapefruit, I give the shadow a thin coat of yellow, yellow-green, orange, and a touch of violet with the No. 5 watercolor brush. While still wet, I hold the board in a flat position and with the tip of the brush, charged with burnt sienna and raw umber, I dab on the specks and spots. Now using Indian yellow, yellow, orange, Prussian blue, and white (included in the box) I paint the lights on the oranges. Then, I mix orange, vermilion, and violet for their shadows. The basket comes next using the No. 3 brush and white, Indian yellow, and a whisper of blue-green for the lights. Then, to this mixture I add orange, violet, cobalt blue, and blue-green for the shadows and to define the weaving. I move to the background and rub the side of a No. 7 watercolor brush with thin mixtures of cobalt blue, violet, and Payne's gray for the cool passages, and orange and burnt umber for the warm ones. I dip into the same puddles on the tray to strengthen the cast shadows on the table. To finish the table, I use Nos. 5 and 7 brushes and orange, vermilion, Payne's gray, black-violet, and white, applied in quick, horizontal strokes to render the grain of the wood.

Materials. A short bristle, bright brush and Winsor & Newton water color brushes Nos. 1, 3, 5, 7. No. 2 office pencil. Pelikan color box. Crescent watercolor board No. 112 with 100% rag surface paper.

Step 1. The only thing I trace from the working drawing to the double-thick Bainbridge illustration board No. 80 is the horizon line, so I'll know where to stop the sky. I squeeze a sponge over the Pelikan color cakes so they'll be moist when I begin to paint. Then I pour some Rich Art white onto the butcher's tray and thin it with clear water, using a No. 22 flat sable brush. After rinsing this brush, I transfer puddles of sienna, yellow ochre, and cobalt blue to the tray. With a smaller brush, I work some of the blue into a generous amount of white and temper the resulting blue tint with a spot of sienna to warm it up. Beginning at the top, I apply a thin wash with the No. 22 flat sable in broad, horizontal strokes. My brushstrokes extend about an inch past the borders of the picture. Working my way down, I dip into more white and the yellow ochre and blend wet-in-wet. I add still more white as I near the horizon to get the gradated effect of the clear sky. After the paint is dry, I trace the trunk and limbs and other important elements over the sky.

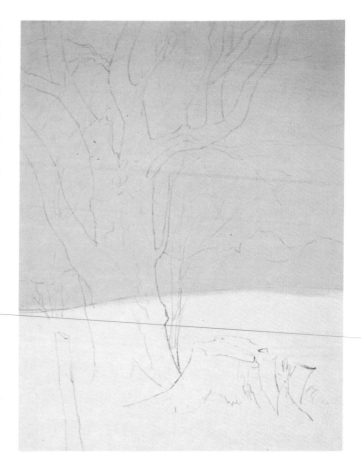

Step 2. I consult the preparatory sketch, and with the side of a No. 5 brush, scantily charged with combinations of ultramarine blue, raw umber, orange, and white, I scumble the band of trees while holding the brush under the palm. I keep the light angle in mind and introduce lights and shadows to give the mass a sense of form. Next, using white, burnt sienna, yellow ochre, and French green, I tap and drag a No. 11 flat sable brush vertically on the light areas of the grass. Then I do the shadow areas with a No. 5 brush, using Indian red, yellow ochre, and cobalt blue, letting the last color dominate to make the shadows cool against the warm sunlit areas. As I work my way to the foreground, I add more color and less white to deepen the value. I mix the shades and tints on the tray as I proceed, to get "broken color"—a heritage from the Impressionists in which individual hues, not thoroughly mixed, produce a vibrant passage rather than the dead coat of paint that results from using a previously stirred batch. Since the star of the show is coming up next—the tree—I place my sketch close by.

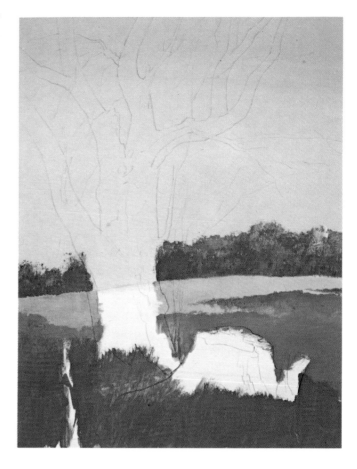

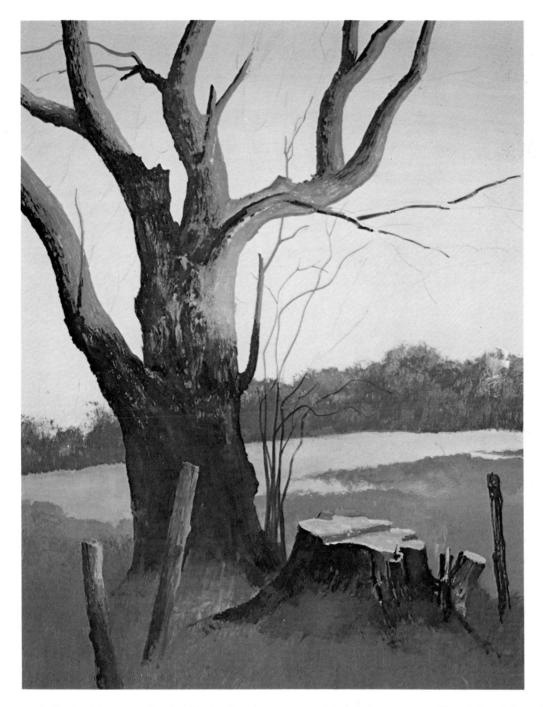

Step 3. I suggest the bark of the tree, using the side, heel, and tip of a No. 3 brush dipped into thin mixtures of ultramarine blue and Indian red. First I paint the shadows on the trunk and branches. Then, adding white, orange, and French green to that mixture, I do the light areas, overlapping them slightly into the shadows to soften the edges and create the basic cylindrical forms. Next, I indicate the stump at the base of the tree with the Gamma grays Nos. 1–5 and flat sable brushes Nos. 1, 2 and 11. At this point, I'm not satisfied with the composition so I place a piece of acetate over the painting and tentatively introduce the other two posts. This is much better, as the posts increase the depth of the picture. I remove the acetate, paint them in, and then indicate the bush by the trunk.

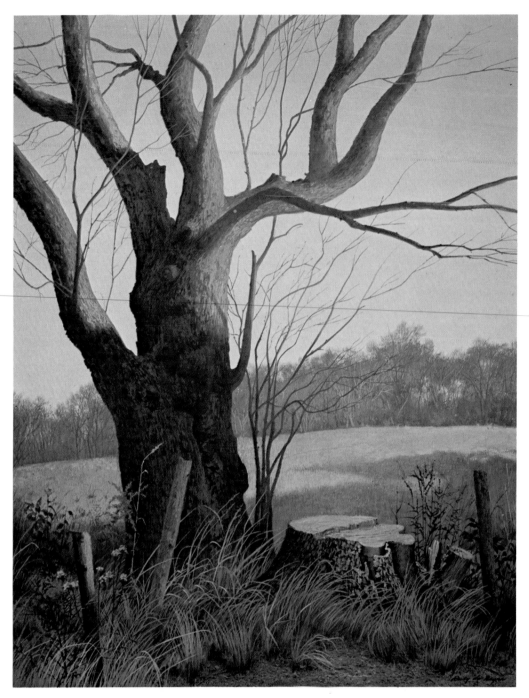

Step 4. With the same colors but thicker paint, I work my way from the back forward. Tackling the band of trees with my hand on a mahlstick and using a No. 1 brush, I render the top edge, sweeping the point of the brush upward and with left and right diagonals into the sky. Then I glaze and scumble with ultramarine blue, raw umber, orange, and white, dimming the sunlit areas and showing bits of sky. Then, using brushes Nos. 1 and 2, I paint the trunk, the limbs, the branches, and the twigs. I define the grass with a fanned No. 3 brush, stroking down to get the short grass effect with orange, blue-green, Indian yellow, and white. I move to the shadows on the grass and paint them with the same brush and green deep, orange, and black. Now consulting the sketch I distribute the weeds with a No. 1 brush, contrasting dark against light and light against dark.

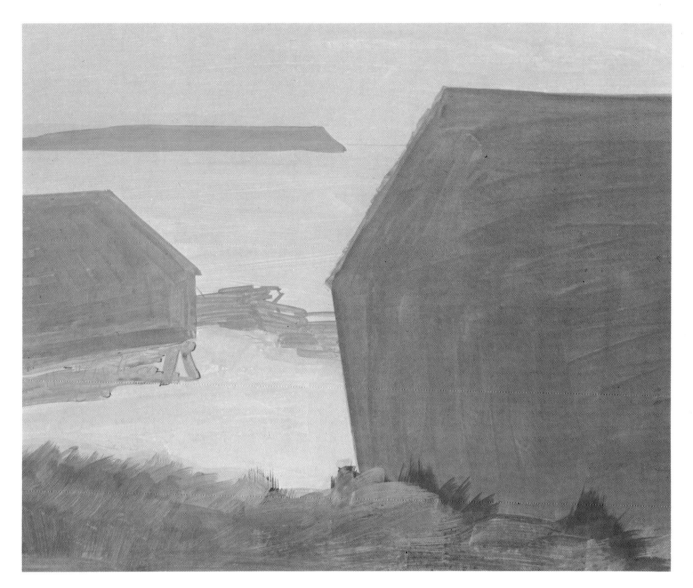

Step 1. Although I didn't show it I did a 16" x 12" pencil study recording the scene's most minute detail and a color sketch as well. Now I enlarge that study, using the "squaring off" method. Then on my illustration board I trace only the contours of the big shapes. These I fill in using flat tones which are mixtures of flame red and brilliant yellow. I use very thin paint and apply it with the No. 20 flat sable. The mauve of the buildings I create from a mixture of alizarin crimson and Winsor blue, adding black or white to create values. I stress the use of thin paint because I'd like you to remember that my realist technique consists of piling up thin layers of paint—whether opaque watercolor, or acrylic—to achieve particular colors, tones, and textures. (I feel I couldn't have done the painting from either the color sketch or from the pencil study alone. I needed to refer back to the information that each had to offer.)

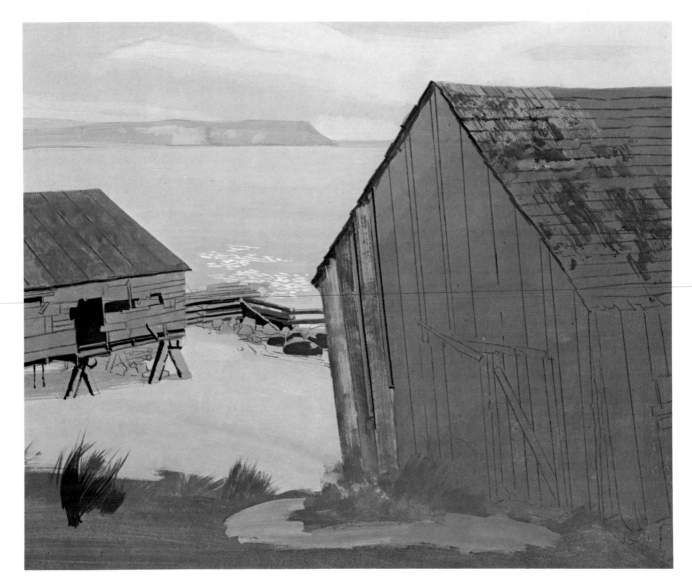

Step 2. Now I tape the 16″ x 12″ pencil drawing that contains all the detail over the flat color areas that I painted in Step 1. Then I trace the details from the drawing lightly in pencil on top of the large shapes. I use the wet-into-wet method to lay in the sky and the water; for them I use Winsor blue and alizarin crimson. On the boards of the barn in the foreground I use a drybrush technique to obtain their weatherbeaten texture. In black, I delineate the trusses that support the barn so that as I apply the shadow beneath the barn, I won't obliterate them. For the underpainting of the water I add a pinkish tone in the distance with a mixture of white and alizarin crimson. There's a bluish tone in the middle ground which is a combination of Winsor blue and white. In the foreground my water becomes a more gray tone—a mixture of alizarin crimson, Winsor blue and white. With an off-white, I begin indicating the shimmer and texture of the water, using the point of the No. 3 brush. Then, with the side of the No. 5 brush, I apply the texture of the shingles on the roof across my traced horizontal pencil lines. I also begin articulating the individual shingles. To convey their weathered and dilapidated condition, I take a damp sponge and tap with it to blur and soften them.

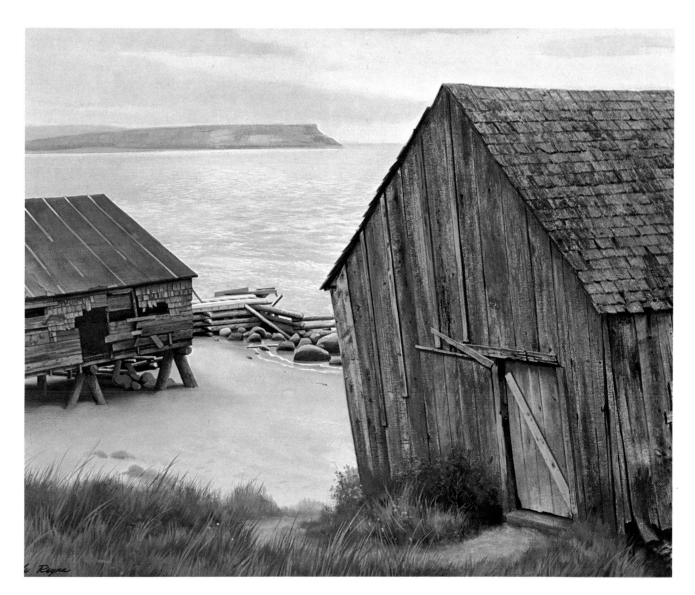

Step 3. What remains at this stage is a matter of sustaining the mood and the feeling that first prompted me to record the scene. I do this by rendering the details so characteristic of my realist approach. A good system to follow when working on the "grays" of the buildings is to distribute the mauve tones all at once (as I did in Step 1). Then successively apply all the yellows, all the greens, and all the blues, to prevent having to mix these tints over and over again. I finish the sky, the water, and the barns in that order. Then I tackle the foreground. I use a mixture of brilliant yellow, Winsor blue, and white for the grass. I flip the No. 3 brush upward, just as the blades of grass grow, to render its detail. For the low bushes near the doorway, I stipple color with my sponge. For the rocks in the water, I use mostly black and white with accents of flame red and brilliant yellow.

Materials. Strathmore drawing pad. Aquabee tracing paper, Bainbridge illustration board (15" x 20") No. 80 double thickness, regular surface. Nos. 3, 5, 7 watercolor brushes, plus No. 20 flat sable. Opaque watercolors: alizarin crimson, flame red, brilliant yellow, Winsor blue, permanent white, ivory black.

Step 1. To begin, I first do a pencil drawing on the Ad Art No. 307 sketch pad with an office pencil. With this sketch I work only for construction and modeling. Then I trace the outline of this drawing onto the illustration board. Next, while still observing the model, I prepare a flesh tone, using a combination of flame red, yellow ochre, and white, that will serve as the middle value for her face and neck. I apply this color with a No. 7 brush, and then mix a light blue tone on the butcher's tray for the background. But, first, before applying it, I dampen the surface of the board. Then I spread the blue paint with a No. 20 flat sable quickly in all directions to get an even tone.

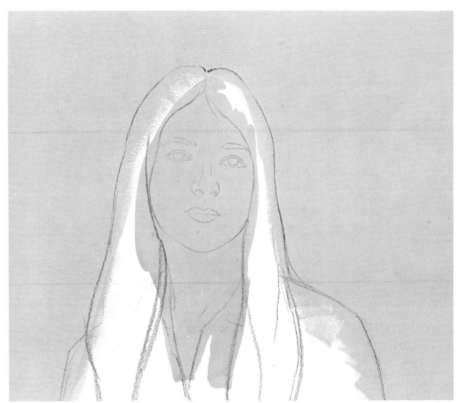

Step 2. The traditional background for a portrait is a screen behind the sitter. You can also just select a color that suits the subject for the background of your painting. Here, my thinking was: young girl equals clear skies, bright and shining prospects. But visually the background turned out to be too cold. So here I go over the background with a mixture of mostly white, a touch of raw umber, and just a whisper of Winsor blue. Then, following the penciled outline, I paint in flat tones for the hair, using raw and burnt umber. For her blouse, I use alizarin crimson, Winsor blue and white. I establish her features and begin to create shadows on her face using a drybrush technique. Checking the model, I find the darkest values to be at the top of her head and on her hair next to the sides of her face. In these areas I add black to the raw and burnt umber. I execute the soft transitions on her face with the No. 3 brush, fanning this brush and sweeping lightly over the initial flat flesh tone.

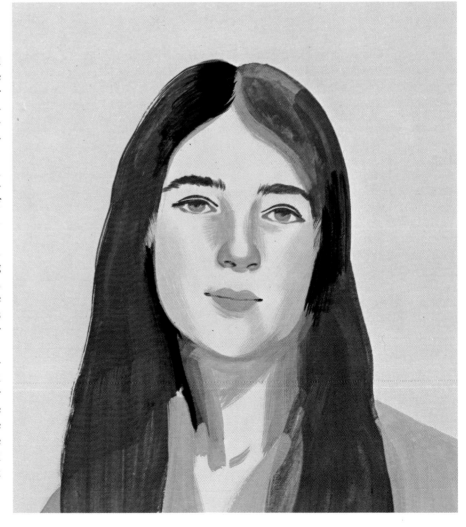

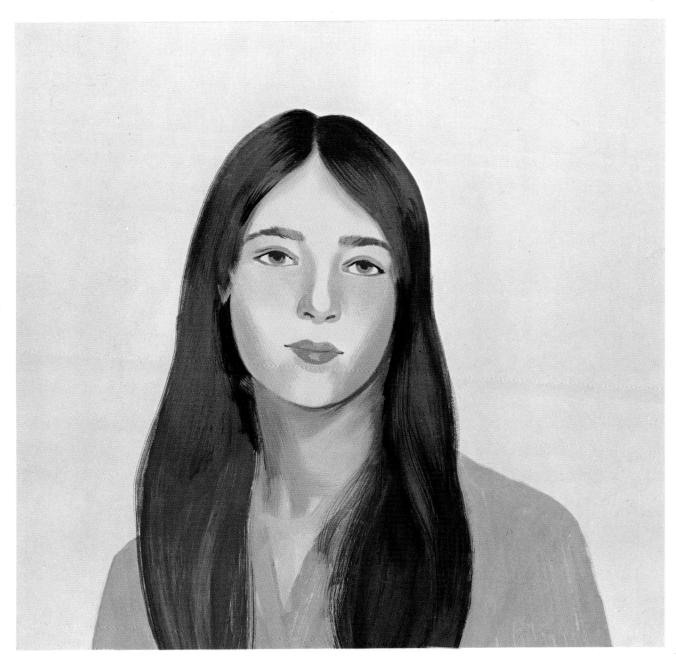

Step 3. I'm not satisfied with the background yet. Here I make it still a bit lighter and take it into the contours of the face. This shows how easy it is to change a color when working with opaque watercolor. Again, working from the model which I place about four feet away from me, I regain the contours of the face and start to render the hair using drybrush in long sweeps with the No. 5 brush. For hair that's in the light, I use yellow ochre and white. I add black for the hair that's in shadow. Then I work on her eyelids, her cheeks, her chin, and her neck to carry the picture forward at the same pace. I use flame red and white for her lips and Winsor blue, yellow ochre, and white for her irises. As I model the face and neck, I swing the strokes beyond the contour of her face into her hair without fear of disturbing a finished area. If I had finished her hair first then I'd feel constrained about working on her face.

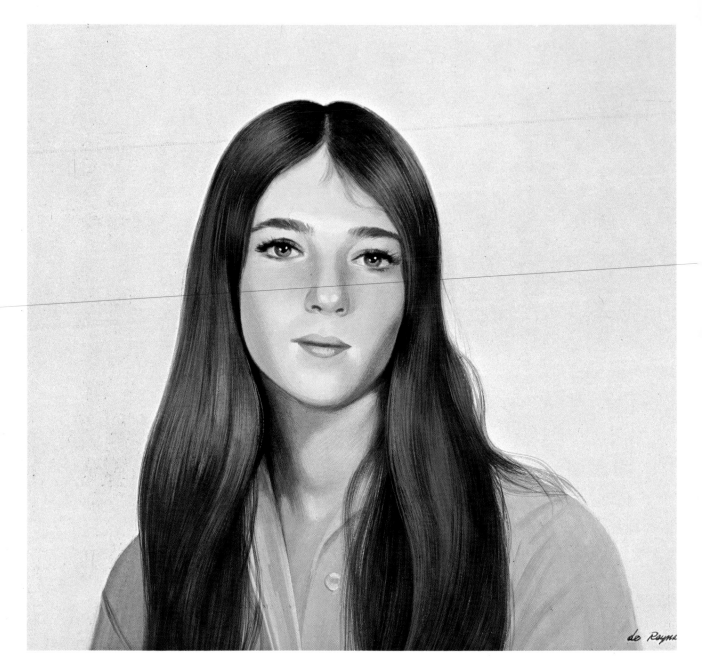

Step 4. Having established the color and the value of her hair, I move to her face and finish it completely. The posing becomes easier for the model as I go along; since the drawing is already established, all I'm checking now is her coloring. I've demonstrated this procedure because it's a very practical approach. First, you can focus all attention on capturing gesture and likeness in the pencil drawing, without worrying about color. Then you can tackle color as a second problem separate from the first, and thus the entire job becomes half as difficult. I go on to her blouse and work it slightly into her hair, which I finish last. I define strands of hair with drybrush over her blouse and against the background over the left shoulder. I add highlights on the tip of her nose, her irises, and her mouth with white and a touch of yellow ochre. I also add such finishing touches as upper and lower eyelashes. I use black and burnt umber for these. I define the separation of her lips with alizarin crimson and burnt umber.

Materials. Ad Art pad No. 307. Office pencils and a 5H. Watercolor brushes Nos. 3, 5, 7 and No. 20 flat sable. Opaque watercolors: alizarin crimson, flame red, yellow ochre, Winsor blue, raw umber, burnt umber, ivory black and permanent black. 20″ x 15″ double thickness Bainbridge illustration board.

Step 1. After again setting up the still life for the painting, as I did for the preliminary sketch, I pour some Liquitex gesso in the butcher's tray. Then with the edge of the credit card I scoop up a portion and scrape it over the wall area, using the corner of the card to get into the small shapes. I move to the blade of the knife and give it a wash of titanium white with the No. 5 brush, to serve as a reflection of the bread. Then, with the edge of a ½″ synthetic sponge I pick up the undiluted white from the tray and tap it on the white of the bread, including the slice under the knife. After diluting some white to medium thick, I scumble the towel with a No. 5 brush. I'm using the tone and color of the support by letting it show through wherever it serves my purpose.

Materials. Brushes: No. 22 flat sable by ArtSign, No. 20 red sable and Nos. 1, 2, 3, 5, 6 pointed white sable brushes by Simmons. An expired credit card. Sponge. Gesso. Liquitex colors: Hooker's green dark, cadmium red light, yellow medium azo, yellow oxide, burnt umber, titanium white, pthalo blue, ultramarine blue, naphthol itr crimson, cadmium yellow light, dioxazine purple, cadmium orange, burnt sienna.

Step 2. After squeezing a spot of Hooker's green dark on the tray I dilute it to a watery consistency with the No. 5 brush and apply it to the top of the bottle. Next, I press a ¼″ of cadmium red light into a nesting cup, proceed to do the same with the yellow oxide and burnt umber, and then paint the crust of bread with the same brush, using washes of all three colors. To render the straw cradle, I take a No. 20 flat sable and dip into the nesting cups containing phthalo blue, yellow oxide, cadmium red light, and white. With the same brush I move to the woodwork and give it a partial wash— leaving some of the board untouched, using burnt umber, yellow oxide, and ultramarine blue, but no white.

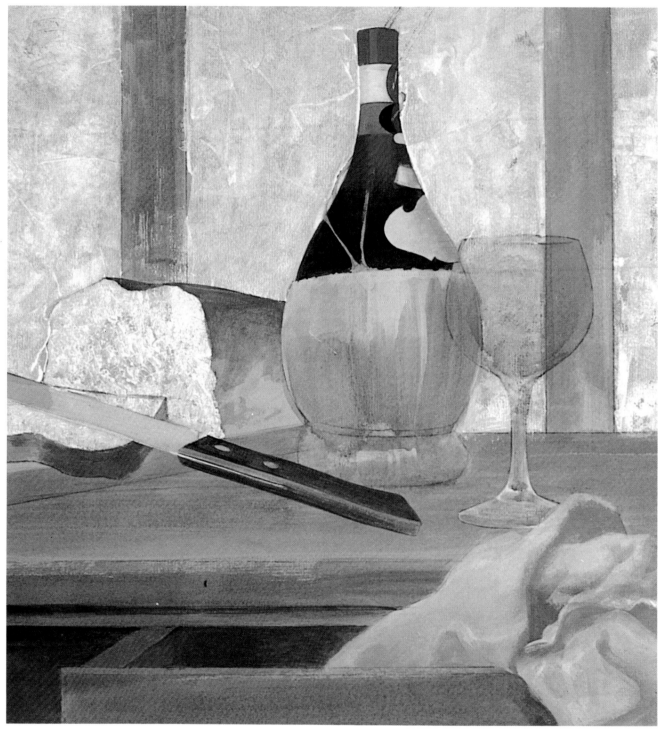

Step 3. I pick up the No. 22 flat sable and stir a watery wash of yellow medium and yellow oxide, tempered with a whisper of ultramarine blue and float it over the wall. To the yellow puddle on the tray I add more ultramarine blue and burnt umber and work it on the straw cradle, and continue with it for the darks on the counter. For the whites on the bottle, I use white and varying amounts of burnt umber, yellow oxide, and ultramarine blue, as they turn into the shadow. Then I trim them with the wine which is naphtol itr crimson (itr is darker), cadmium red light, ultramarine blue, and white. I use the same colors for the red foil at the top and the red labels, with the No. 3 brush. Now I glaze the glass—after whiting out the counter across the stem—with burnt umber, yellow oxide, and ultramarine blue, using the No. 5 brush. Switching to opaque paint again, I work on the napkin with white and whispers of alizarin crimson, yellow oxide, and ultramarine blue. After adding burnt umber to the above colors, I paint the knife's handle.

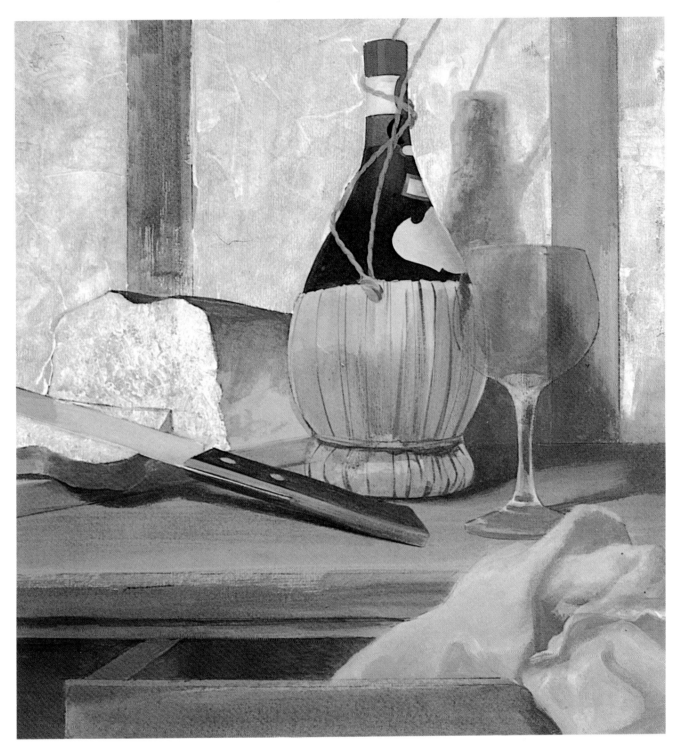

Step 4. Constantly checking the still life before me, I paint the bottle's cast shadow with Nos. 5 and 6 brushes, using cadmium yellow light, phthalo blue, ultramarine blue, yellow oxide, burnt umber, and white. The same for the cast shadow of the glass. I pick up the No. 3 brush to work on the bottle's twine handle—using white, napthol itr crimson, yellow oxide, ultramarine blue, and burnt umber. With the same colors and the same brush I do the linear articulation of the straw cradle, and the distortion of the slat seen through the wine glass. That blinking slat on the left has been bothering me for a long time; it breaks up the picture into too many areas of equal size. I didn't notice it in the sketch; but I will remove it now.

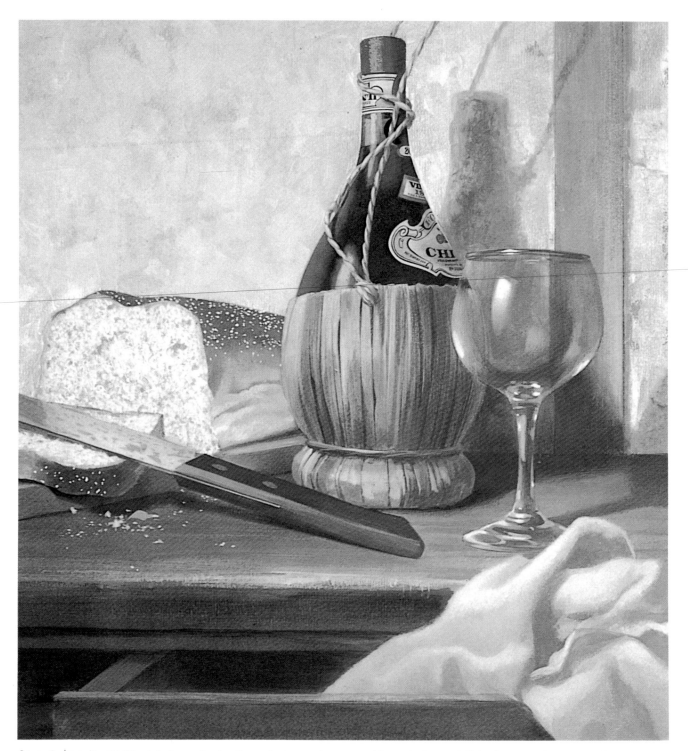

Step 5. Details. (1) The labels on the bottle: cadmium red light and mixtures of alizarin crimson, ultramarine blue, and burnt umber, to make the black for the scroll and the lettering—using No. 1 brush. The gold on the labels: Hooker's green dark, cadmium yellow light, yellow oxide, and white. The wine, twine, and scarlet top: alizarin crimson, cadmium red light, cadmium yellow light, yellow oxide, burnt umber, Hooker's green, dioxazine purple, phthalo blue, and white. (2) Dipping into the colors for the bottle I do the glass, developing sharp and soft-edge reflections, going up to pure white, with the No. 2 brush. (3) With the No. 3 brush I modify the color of the crust and do the corrugations on the side of the bread with cadmium orange, burnt sienna, yellow

oxide, cadmium red light, burnt umber, and white. Then I do the cut end with white, yellow oxide, burnt sienna, and ultramarine blue—and add more hollows, matching those originally left by the color of the mat itself. (4) For definition on the straw cradle I use No. 5 brush and cadmium yellow light, yellow oxide, Hooker's dark green, burnt sienna, burnt umber, and white. (5) I deepen the left side of the counter with glazes of burnt umber and ultramarine, using No. 20 flat sable. (6) I finish the napkin with alizarin crimson, yellow oxide, ultramarine blue, and white with the No. 6 brush, taking care to convey the cloth. (7) For salt on the bread: white and yellow oxide, and a No. 1 brush.

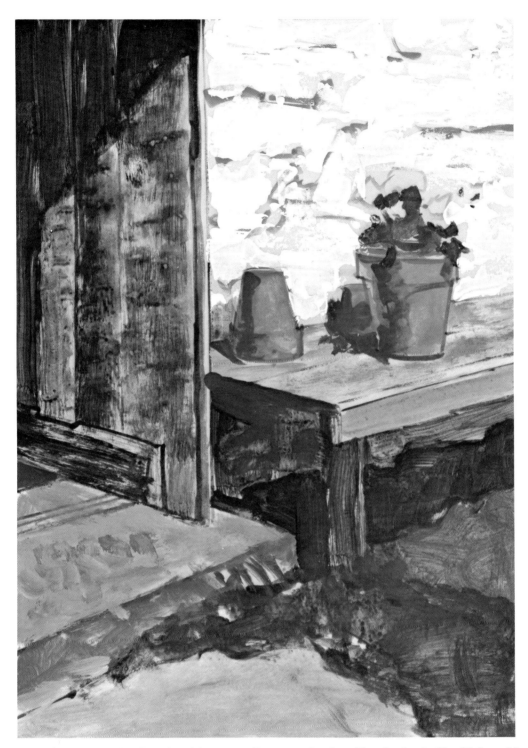

Step 1. After making a color sketch and making a pencil line drawing from it on the 20″ x 30″ illustration board, I use the No. 6 flat and the No. 4 bristle bright, to reinforce the pencil outline with burnt umber acrylic everywhere except on the pots. On them I use the No. 5 pointed red sable for more accurate delineation. I paint in the entire composition using only two colors: Hooker's green and burnt sienna. These also give me a chance to see how the cool (Hooker's green) and warm (burnt sienna) areas are going to balance each other. Now I take the No. 20 flat sable and cover the vertical wooden wall of the entrance, the top of the bench, and the ground with the two colors. Next, I use my painting knife to apply a thick impasto to the stone wall with white acrylic straight from the tube. I pat the paint with the flat side of the blade to build up the wall's texture; I scrape with the edge of the blade to make its cracks. I've made no attempt to finish, but work quickly and broadly on all areas of the picture to cover its surface completely.

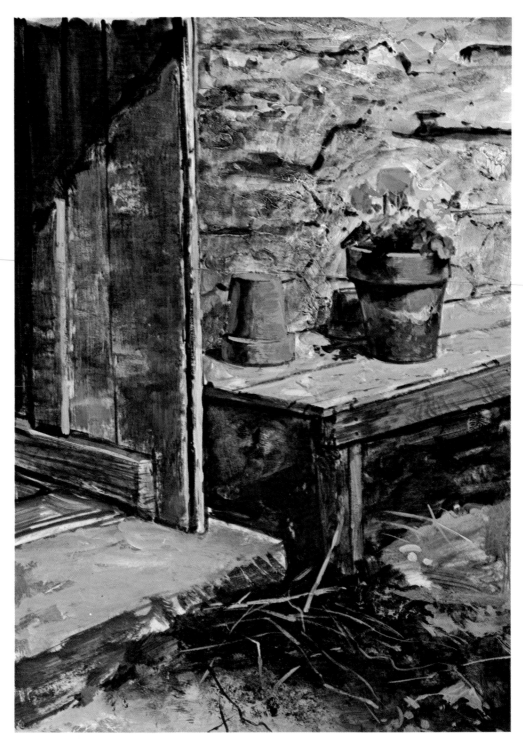

Step 2. I place the illustration board down, almost flat, so that the glaze I'm going to put on the stone wall won't run off. I squeeze some water from the sponge onto my butcher's tray, and dip one corner of the No. 20 flat sable into burnt sienna and the other corner into Hooker's green. Then I work both colors into the puddle of water on the tray until I have a tint that's as close as possible to the color of the stone wall. As I work, I'm ready with a rag to rub off—but none too briskly—the areas where I want a lighter value. The only spot where I wipe off the glaze completely is within the outline of the geraniums. Here I need a pure white underpainting because the bright pinks would be dulled by the wall's glaze. I spread some burnt sienna in the foreground, some Hooker's green under the bench. I even put some cerulean blue on top of the bench, so that the demarcation between the pot and the bench won't be so abrupt.

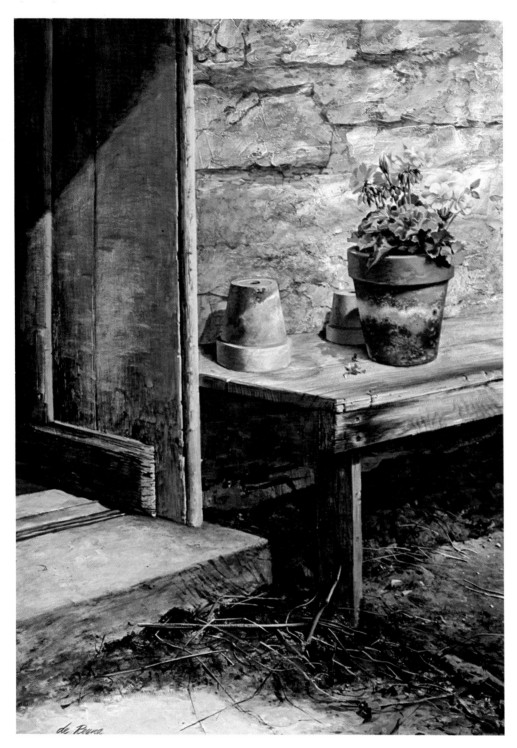

de Berna

Step 3. I've brought the actual flower pots into my studio to scrutinize at close range the green mold on them and to study and define the flowers with authority. Both the geranium leaves and blossoms are painted wet-in-wet for smooth transitions of tone and color. I do the mold on the pots by tapping and dragging the side of Nos. 3 and 5 watercolor brushes, loaded with thick Hooker's green and black pigment. For authenticity in the final rendering, I bring indoors a shovelful of soil and handfuls of leaves and twigs. After arranging them on the floor in the same composition that I had in the previous steps, I mix on the butcher's tray with burnt sienna, white, and black a dark color which

matches the soil. For the rest of the ground I use burnt umber, ultramarine blue and white on top of the burnt sienna and green that I've previously laid in. Now I can go back to the painting and finish the twigs completely, as well as the tiny pebbles under the bench. Then I go to the steps and the wooden entrance where (after consulting some discarded boards that I'd saved for just such a purpose) I add some nail holes.

Materials. 11″ x 14″ Aquabee No. 1171 sketch pad. Brushes: No. 6 flat bristle, No. 4 bright bristle, No. 20 flat red sable, and Nos. 3 and 5 pointed red sable. A painting knife. Sponge. 20″ x 30″ plate finish, double thickness illustration board.

ACRYLIC: LANDSCAPE

Step 1. I'm using a 16" x 20" canvas board — cotton canvas glued to cardboard — with liquid acrylic. After transferring the drawing to the canvas board, I ink in the main lines of the bridge with a No. 303 Gillott pen and Artone extra-dense black ink, so that when I indicate the sky, the lines won't get lost. I put large dabs of naphthol crimson, yellow ochre, and ultramarine blue in three cups so I can squeeze a sponge over them if they begin to dry. I paint the sky with a Simmons No. 6 bristle flat brush, dipping into all three colors, and working them slightly into the dunes.

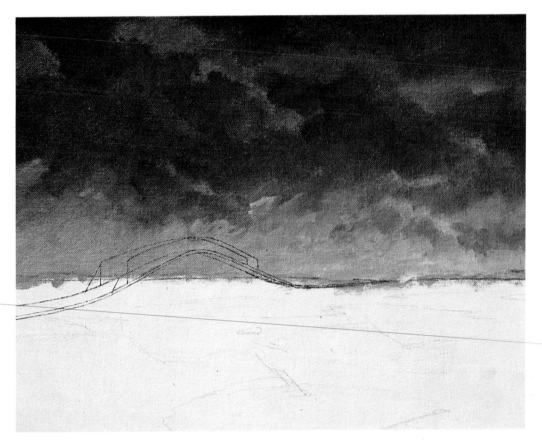

Step 2. Notice that the stormy sky takes more than half the space so that its turbulence and oppressiveness weigh down on the land. I continue on the ground, using as many diagonals as I can to convey the excitement of the scene. With a No. 7 flat sable and titanium white, I regain the contour of the dunes against the sky. I paint the grass on the dunes, tapping and scrubbing vertically with the No. 6 bristle flat, using mostly the blue and the yellow with only a whisper of the crimson. I place the darkest dark (crimson and blue with a touch of yellow) on the ground so I can better judge the values of the marsh.

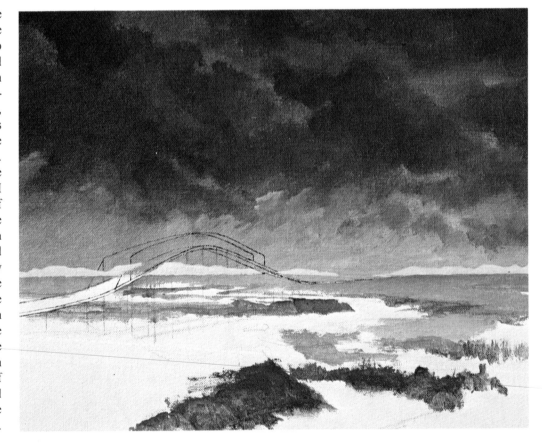

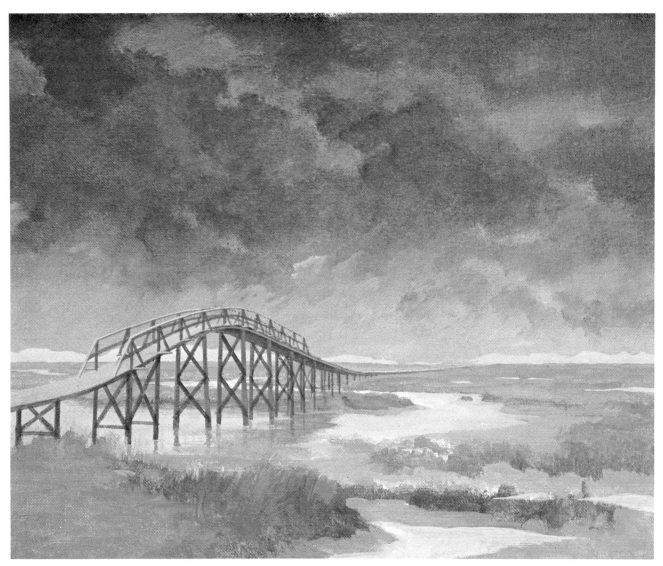

Step 3. Checking additional drawings made on the spot and following the inked lines of the bridge, I tackle its intricate construction, knowing now that its X's will pull the eye to it no matter what I do in the rest of the picture. I want the bridge to play a part second only to the sky because it's such a familiar landmark at Sandwich, on Cape Cod, Massachusetts. I actually saw this dramatic scene, and it haunted me through the intervening weeks while I was engaged in other work. A few days later another storm came our way and gave me the chance to try it. I have of course made the necessary modifications to suit this particular purpose. Any picture not precipitated by emotion isn't worth its pigment — Cézanne once said words to that effect. My point is that you too must be haunted by a scene and feel intensely what you paint, or the "game will not be worth the candle." I continue using only the three colors and white with a No. 7 flat sable for the large areas and brushes Nos. 1 and 3 for the smaller ones. It is at this stage that I relax. The underpainting is done and I've nothing left but the fun of determining the color, accentuating textures, and defining details.

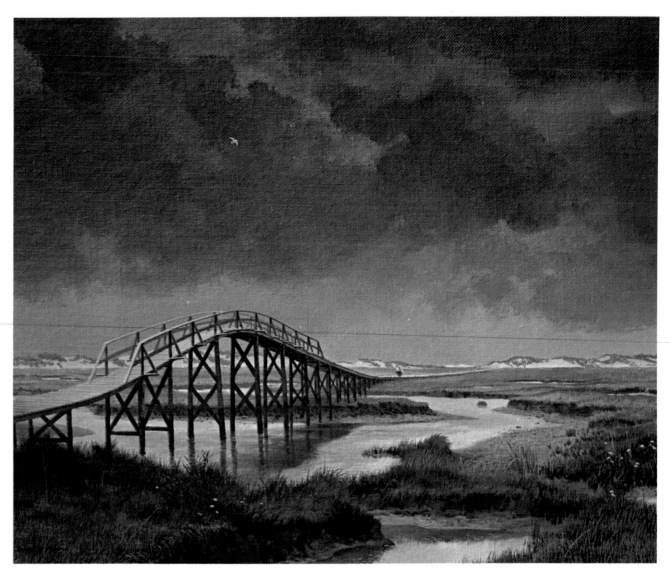

Step 4. I begin to finish the far distance with flat sables Nos. 8 and 10, doing the dunes and the adjacent sky so I can work one into the other while the pigment is still wet. As I work the sky at the horizon with all three colors and white, part of the bridge gets lost. So, checking the pencil drawing, I restore the bridge in ink with the Gillott pen No. 303. Then I move down to the inlets, using thick paint; the trusses of the bridge almost get lost but I can still see them. Next I do the rest of the marsh, adjusting shapes and textures to pull the picture together as a unit. Originally I intended the lower left corner to be bare ground (as it actually is), but the marsh was getting too spotty and began to detract from the stormy sky. So, with a No. 1 brush I extend the grass all the way to the edge. I use a Liquitex yellow-green—Value 7—to do the moss on

the stanchions because the mixture of blue and yellow I've been using isn't vivid enough. Then I paint the tiny figures on the boardwalk with a bit of cadmium yellow light and a No. 00 brush. I know that, as a rule, the gulls lie low and seek shelter during a storm, but fie and forsooth! I need a white speck up there defying the elements.

Materials. 16″ x 20″ canvas board. Artone extra-dense black ink. No. 303 Gillott pen. Acrylic Liquitex paints: naphthol crimson, yellow ochre, ultramarine blue, titanium white yellow-green—value 7—and cadmium yellow light. Sponge. Brushes: Simmons No. 6 bristle flat, No. 1, 3, 7, 8, 10 flat sables, No. 6 bristle flat, No. 00.

Step 1. I begin the warm overall color scheme by giving the sky area a graded wash of yellow oxide, tempered with a whisper of naphthol crimson. Starting at the top, I bring the wash down with a fully charged 1″ watercolor brush. The mixture is in the corner of the butcher's tray. As I descend I add more water and a touch of yellow light to make the sky warmer and lighter near the horizon. Even though the wash is applied to a dry surface the paper buckles a bit, but not to worry, it will smooth itself out when it dries. In a cup I prepare a mixture of naphthol crimson, yellow oxide, and cobalt blue, and test the resulting color on the margin of the paper; it turns out to be too warm so I add more blue. After rewetting the sky area with the 1″ brush I float the shapes of the clouds with the No. 20 flat sable, holding the paper (taped to a piece of chipboard) almost flat with my left hand as I work with my right. The paper is just wet enough to give me soft edges and to control the cloud shapes I want. When the paper is completely dry, I paint the distant horizon with the No. 6 white Sable.

Step 2. Again I wet the entire sky and with the 1″ brush, I give it a flat wash of very diluted naphthol crimson and yellow light. While still wet I pick up the tint with the No. 20 flat sable but only from the areas that I plan for the blue sky. When dry, I rewet only the edges of the blue shape at the upper left corner, float the mixture of cobalt blue with a smidgen of phthalo blue with the No. 6 brush, and work my way across the top, following the same procedure for each blue shape. Then, for the lower sky I add more phthalo blue to the cobalt blue and dilute the tint still more to let the warm underpainting give the horizon a glow. When completely dry, I lighten the lights on the clouds with a Pink Pearl eraser for greater contrast against the sky. Moving to the background I begin the buttes with alizarin crimson, ultramarine blue, and yellow oxide, using the No. 6 brush. As I move to the foreground I combine the Nos. 6 and the 10 flat sables, still using the same colors.

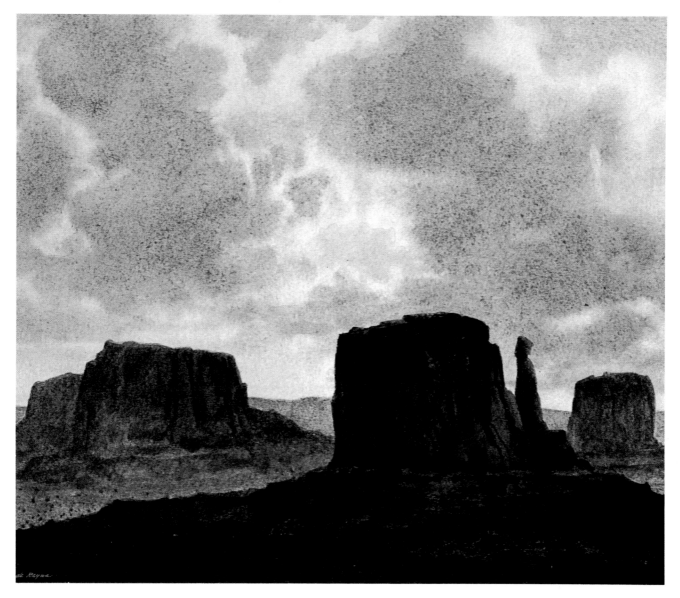

Step 3. Using the No. 5 and the No. 6 brushes with mixtures of alizarin crimson, yellow oxide, cadmium red light, ultramarine blue, Hooker's green, and burnt umber, I deepen the values of the buttes and, consulting the snapshots and the sketch, I render their detail. I'm using the tip of the brushes for the contours and the linear articulations, and then flip them under the palm to rub the side of the sable for the broad passages. And last, I make some minor changes on the clouds with alizarin crimson, yellow oxide, and cobalt blue because there were (check the previous step) too many horizontals hitting the right border of the picture.

Materials. Simmons brushes Nos. 5, 6, 10 and 1″ flat and No. 20 flat sable. Pink Pearl eraser. Kneaded eraser. Liquitex colors: naphthol crimson, cadmium red light, yellow light, yellow oxide, cobalt blue, phthalo blue, ultramarine blue, Hooker's green, burnt umber. Fabriano paper.

ACRYLIC: SEASCAPE

Step 1. After making a color sketch and a pencil sketch from it, I wet the entire 11″ x 13⅜″ picture area with the No. 22 flat sable. Then, holding the board slanted a bit toward me, I take the No. 20 flat with yellow oxide and begin to paint the clouds, spreading the color into shapes that closely resemble those on the sketch. I've erased (before wetting the paper) the traced lines in the distance with a kneaded eraser. After the paper dries, I continue using the same brush and the same color to do the parts of the cliffs that require the warm underpainting.

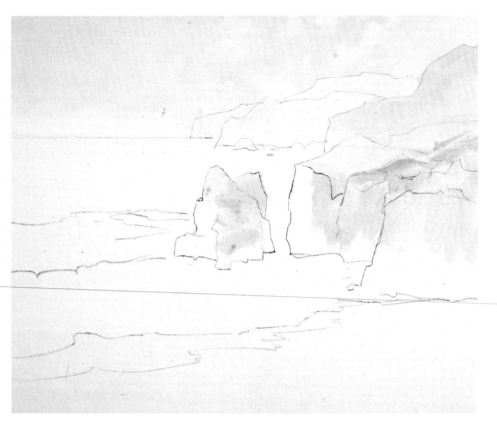

Step 2. First I rewet the sky area with the No. 10 White Sable and then with the same brush I dip into the naphthol itr crimson and ultramarine blue, mix, but not too thoroughly, on the butcher's tray the color that I float over the cloud shapes. I vary the amounts of blue or crimson so that when combined with the yellow underneath, I get the nuances I want. As I work I try not to slap the brush to avoid splattering paint where I don't want it. Then I move to the cliffs and give them washes in varying degrees of dilution, but still using the same two colors.

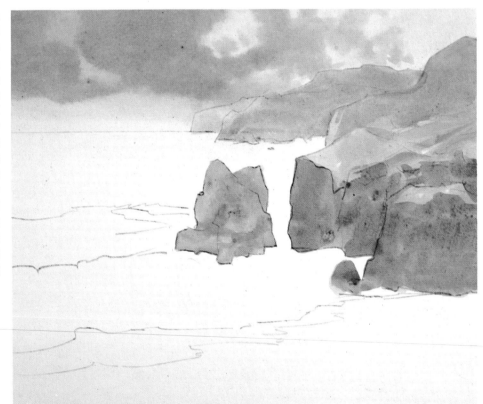

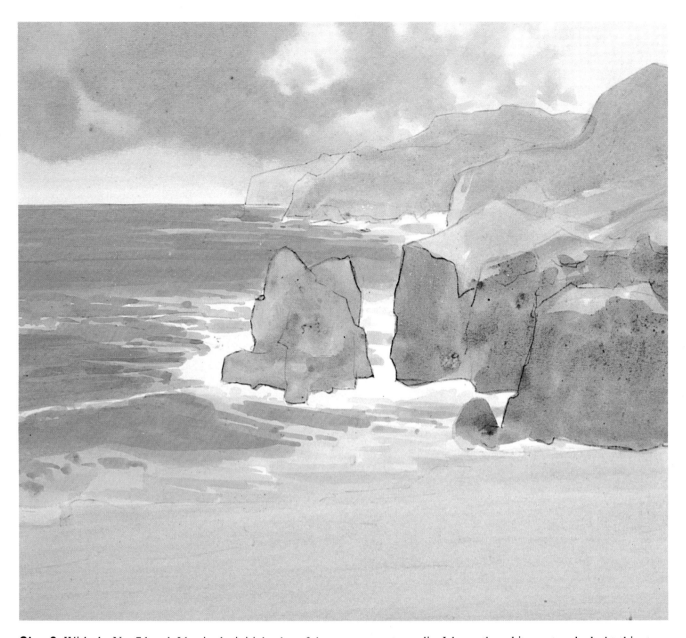

Step 3. With the No. 7 brush I lay in the initial color of the sea, mixing on the tray naphthol itr crimson, yellow oxide, and phthalo blue. Notice that in the beginning stages I've used mixtures of red and blue over yellow, and now all three colors together, letting the blue dominate, but tempered with the other two. With the same colors I paint the sand but let the yellow oxide dominate. Still working in trans- parent acrylic, I leave the whites untouched. At this stage I'm aiming for the middle values of the seascape; later I can place the deepest darks where I want them. I've planned to carry this picture as far as I can with transparent color and then give it the last touches with opaque. So let's continue the washes and glazes.

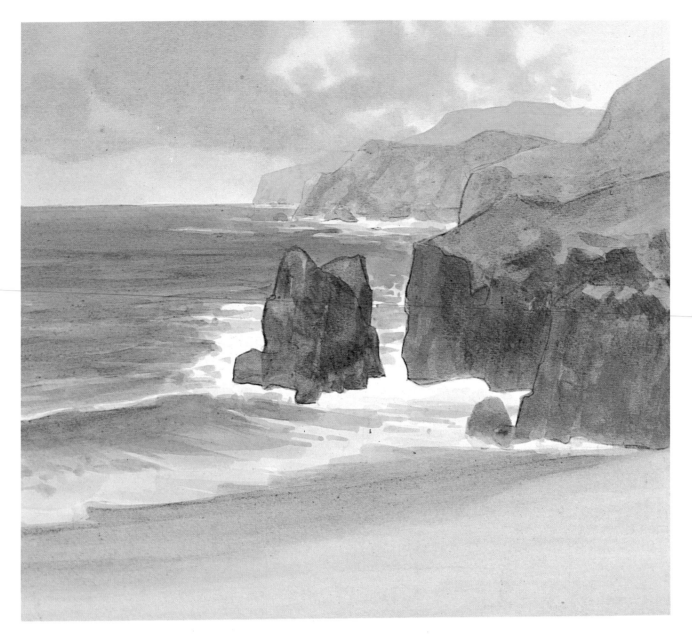

Step 4. After rewetting the sky, I give it additional glazes of naphthol itr crimson, yellow oxide, and ultramarine blue, using the No. 10 brush. With warm and cool mixtures of the same colors I move to the cliffs, switching to No. 5 and No. 6 brushes, and bring them closer to completion. I'm mixing on the tray, adjusting color values as well as the tonal har- mony, using more pigment and less water as I come forward to the darkest, changing to the No. 7 brush. I darken the sea next, adding phthalo blue to the 3-color mixtures on the tray. And last, I do the dark wet sand after wetting the near edge to make it soft.

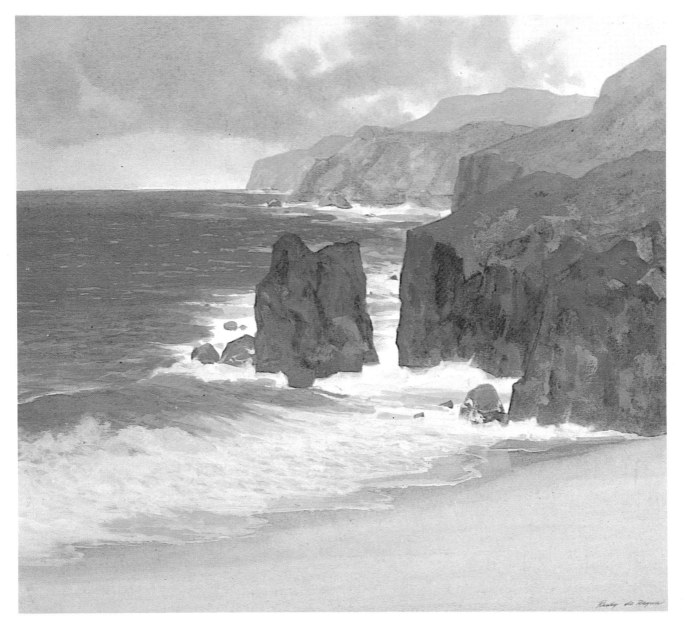

Step 5. Now as I planned, I add white to mixtures of naphthol itr crimson, yellow oxide, ultramarine blue, and phthalo blue. First the sea, beginning at the horizon and working my way down I deepen the color and subdue the swells, with the No. 3 brush. Then I switch to the No. 5 brush to do the white foam of the spent wave. I'm loading the whites thickly, but with whispers of alizarin crimson, yellow, and blue. I do the cliffs next with Nos. 5 and 6 brushes, subduing, emphasizing,

modifying, but especially darkening and cooling their faces. I also add some smaller rocks. The last touches are the white caps on the sea which I lay in with a No. 3 brush.

Materials. Simmons white sables Nos. 3, 5, 6, 7, 8, 10 plus two flat sables Nos. 20, 22. Liquitex colors: naphthol itr crimson, yellow oxide, ultramarine blue, phthalo blue. No. 80 Bainbridge cold pressed board. (Any paper will do.)

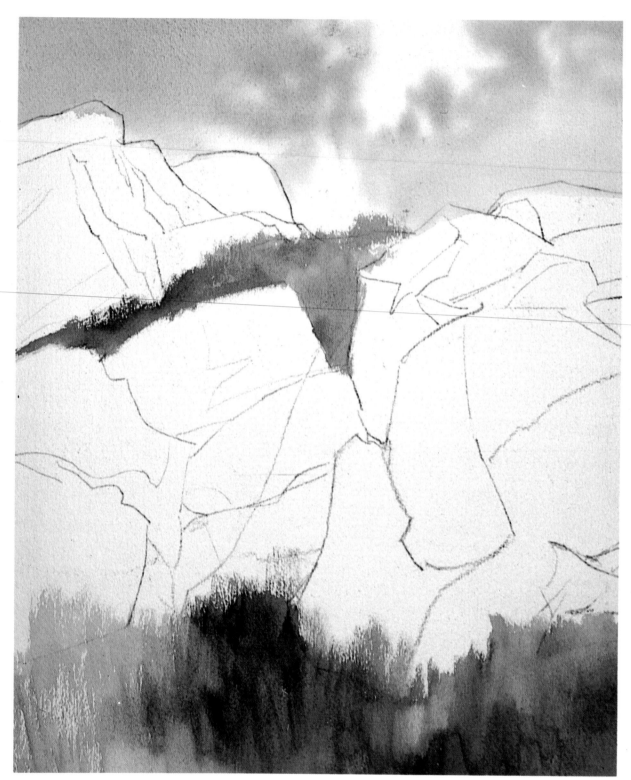

Step 1. Here again I made a color sketch and a line drawing from it. Next, with the No. 7 pointed sable, I mix on the tray equal parts of blue-green and blue from the Grumbacher Symphonic set and test the tint on the margin of the paper. Then I turn the paper upside down and wet the sky area with the No. 22 flat sable. Turning the paper right side up while still quite wet, I float the color on it with the same brush. I leave the white and almost white shapes as clouds. When the paper dries I place it back on the 35 degree angle of the drawing table. Then I rub the orange on my palette with the wet No. 4 bristle bright and transfer the color to the butcher's tray, rinse the brush and follow the same procedure until I've transferred spots of yellow-orange, red-violet, and violet. Next, dipping into them for tints and shades I scribble the dry grass using the edge of the No. 4 bristle bright in up-and-down strokes. Now with the No. 7 brush I lay in the rocks, on dry paper, with mixtures of violet, blue, brown deep, and yellow ochre. As I rub the side of the brush quickly over the rough paper, some white specks are left at the base of the rock on the right. Instead of filling them in I decide to leave them and develop them later as wild daisies.

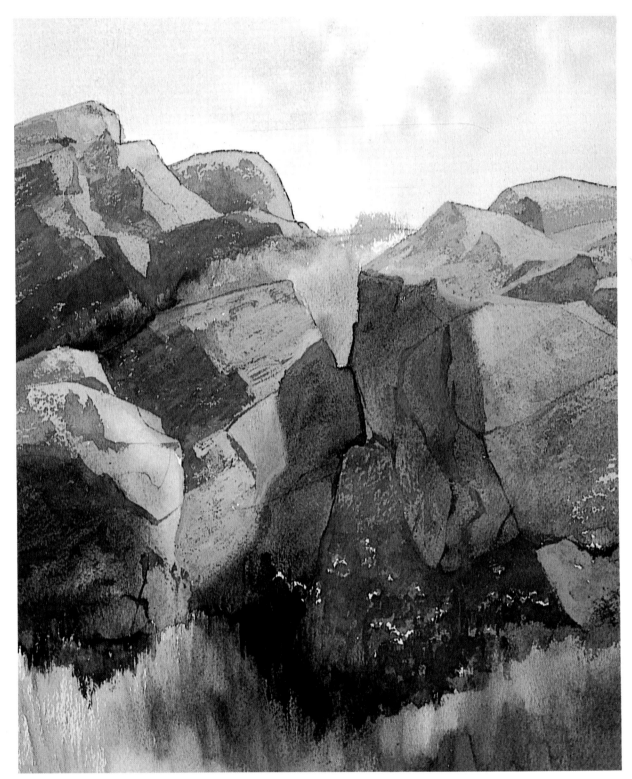

Step 2. A quick lay-in of the three main masses—the sky, the rocks, and the grass—is the advantage of using this fast-drying transparent medium. Now I can easily see by comparing one against the other that both the sky and the grass are too intense. The first thing I do is rub the sky with a kneaded eraser; later I will subdue the grass when I paint it with opaque. Then I bring out the form of the rocks with lights and shadows, using the tip and side of a No. 6 White Sable with alizarin crimson, yellow ochre, ultramarine blue, and white.

Step 3. Now I begin to pull the picture together by enlarging the cloud with white and whispers of red, yellow, and blue from the Symphonic, using the No. 6 brush. The rocks come next, I work on both the shadow and the light areas and watch the warm and the cool color values as well as the tonal scheme of the whole picture. I'm still using red, yellow, and blue plus white. I use the No. 1 and the No. 2 brushes for the smaller cracks and the No. 3 for the larger ones. Deciding to keep the white (paper) specks as flowers I work round them as I paint the darker values behind them with the No. 6. Then I add more wild flowers with the No. 1 brush and white. With the side and the point of Nos. 2 and 3 brushes I do the grass adding opaque brilliant yellow to the mixtures on the tray.

Materials. No. 22 flat sable. No. 4 bristle bright, Nos. 1, 2, 7 pointed red sables, Nos. 3 and 6 pointed white sables. Opaque colors: alizarin crimson, yellow ochre, brilliant yellow, ultramarine blue, burnt umber. Transparent colors from Symphonic set No. 30/17. 140 pound rough Fabriano.

Step 1. First I made a color sketch and drawing. Next, after pouring some gesso on the tray, and loosely mixing a bit of phthalo blue and raw sienna, I apply it to the background with the palette knife just as though I were plastering a wall. Then with a synthetic sponge I tap gesso tinted with the blue on the watermelon areas that will be painted red later. For the finer fuzz of the peaches, I tap the No. 3 stippling brush in the gesso on the tray, add a touch of ivory black, and then tap it within the peaches' contours. I've just prepared the groundwork with acrylic for the transparent color coming up.

Materials.- Bainbridge No. 80 cold pressed illustration board with underpainted areas of Liquitex gesso. Simmons Nos. 12, 20 flat red sables, Nos. 3, 5, 7 White Sables, No. 3 stipling brush. Painting knife. Sponge. Paper towels. Liquitex acrylic colors: naphthol crimson, cadmium red light, yellow medium, yellow oxide, ultramarine blue, phthalo blue, dioxazine purple, raw sienna, burnt umber, ivory black, titanium white. Transparent colors from Grumbacher's Symphonic set No. 30/17.

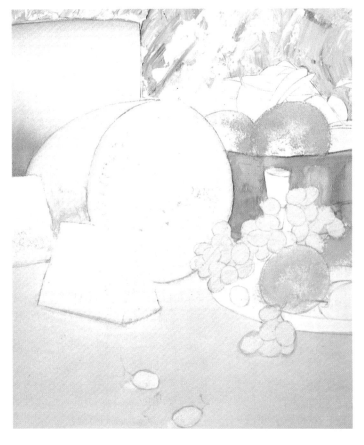

Step 2. With the No. 12 flat sable I wet the yellow, yellow-green, yellow ochre, blue-green, and red-orange of the Symphonic set, and dilute this greenish tone on the tray. Then with both the No. 12 and the No. 20 flat sables I begin the modeling of the watermelons, blending wet-in-wet. I make the lights lighter by tapping them while still wet with a crumpled paper towel. After adding yellow-orange, brown light, and a touch of blue to the greenish puddle on the tray, I apply the initial washes to the crate with the No. 12 flat, and to the table top with the No. 20 flat.

Step 3. I wet the ellipse and the slices of the watermelon with the No. 20. Before they dry I float red, red-orange, and orange from the Symphonic set, while studying the fruit set up in the studio. Moving to the background I scrub blue-violet and brown deep over the gesso with the No. 20. Then I do the peach leaves with the No. 3 brush and red-orange, orange, and yellow-green. The plums come next using the No. 5 brush and violet, blue-violet, and orange. Now checking the peaches on the table, I scumble them with scantily charged Nos. 3, 5, and 7 brushes, using yellow-orange, orange, red, red-violet, and blue-violet—taking advantage of the stippled gray underpainting to strengthen the modeling.

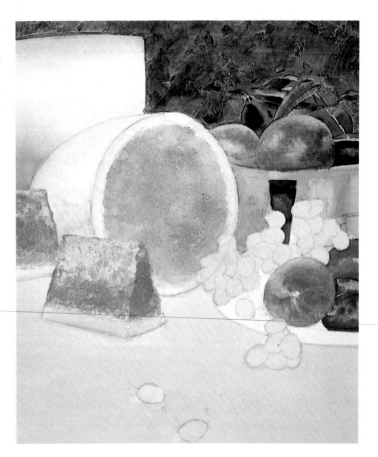

Step 4. I rewet the watermelon slices on the left and in the center with the No. 20 flat sable. Then with the No. 3 and No. 5 brushes and yellow-orange, brown deep, and yellow-green, I deepen the shading and paint the stripes. I'm pushing the painting as far as I can in transparent, planning to clean up and finish in opaque acrylic. I render the grain of the plywood next with orange, red-orange, and blue-violet, using the edge of the No. 12 flat and the No. 3 brush. Dipping into the darker puddles, I render the shadows under the watermelon and grapes.

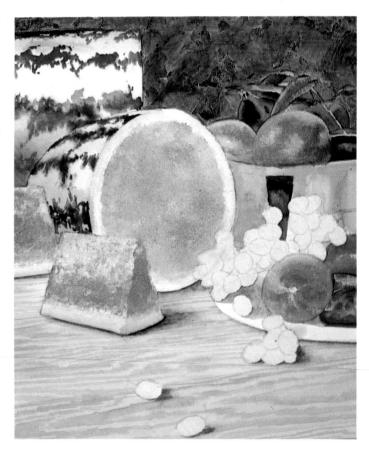

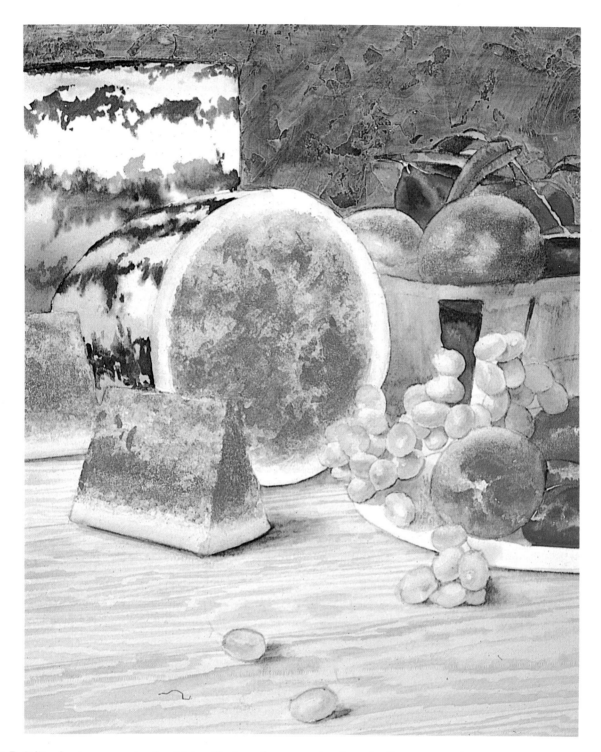

Step 5. Still using transparent color I intensify the reds on the watermelons with red and red-orange. Then I deepen the values on the basket with blue-violet, brown light, and yellow-green using the No. 5 brush. I switch to the No. 3 brush and yellow-green, yellow-orange, and brown light to model the grapes, blending wet-in-wet. This is as far as I'll take the transparent groundwork for the final rendering in acrylic.

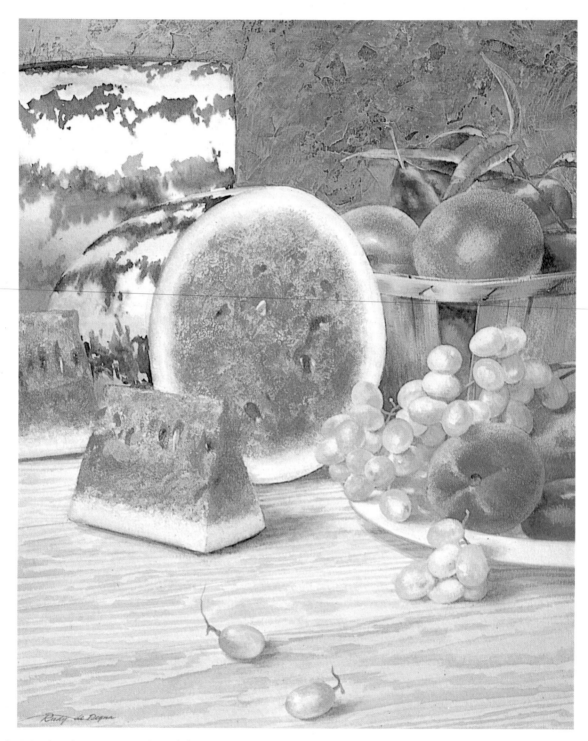

Step 6. I begin with the plums by mixing purple, ultramarine blue, phthalo blue, burnt umber, and white, and use the No. 3 brush. To do the peaches, I scumble rather thick paint with Nos. 3 and 5 brushes using yellow oxide, yellow medium, cadmium red light, alizarin crimson, ultramarine blue, and white. Adding purple to the peach colors I do the leaves, painting a new one to improve the silhouette. With the same brushes I finish the basket using burnt umber, yellow oxide, yellow medium, and white. I go over the watermelon reds with naphthol crimson, cadmium red light,

purple, and white—and then the seeds with burnt umber, ultramarine blue, yellow oxide, and white. The rinds come next using white, yellow medium, yellow oxide, and a whisper of phthalo blue. Following this, I render the final details on the grapes with white, yellow medium, yellow oxide, ultramarine blue, phthalo blue, and alizarin crimson. And last, I lighten the upper left corner with alizarin crimson, yellow oxide, ultramarine blue, burnt umber, and white; and then I do the shadow under the plate with the same colors.